SAM FRANCIS

Kunstverein Ludwigsburg
Louisiana Museum of Modern Art, Humlebaek
Städtische Kunstsammlungen Chemnitz

SAM FRANCIS
The Shadow of Colors

Edited by Ingrid Mössinger

Texts by

**Peter Iden, Knud W. Jensen, Ingrid Mössinger, Tilman Osterwold, Robert Shapazian,
Wieland Schmied, Nancy Mozur, Kiki Kogelnik, Pontus Hulten, Nico Delaive, Susanne Anna
Sam Francis**

E DITION S TEMMLE

Sam Francis
Palo Alto 1992
Photo: Nico Delaive

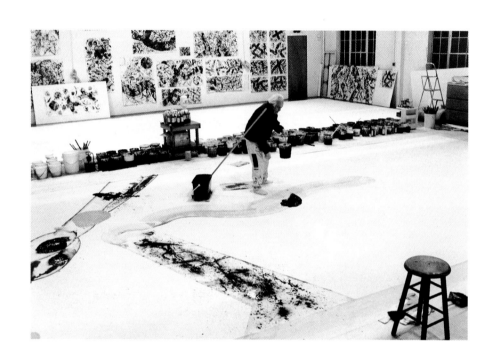

Contents

When I first visited Sam Francis' studios in Santa Monica and Palo Alto, I noticed, alongside his large grid paintings, a few small framed works on paper propped up against the wall. Unlike the glowing colors Sam Francis generally preferred to use, these were dark, almost black. Some of them even reminded me of the almost ethereal brushwork of Mark Rothko, whose paintings Sam Francis had seen at the San Francisco Museum of Modern Art as a young man. Not only individually, but also – and indeed especially – when seen lined up together, they created a magnificently vibrant suffusion of browns, greys and blacks, interrupted only by the occasional flash of color. I immediately wished I could show these works in Europe in order to share my enthusiasm with as many others as possible. For this reason, I am particularly pleased that they are now being exhibited not only at the Kunstverein Ludwigsburg, but also at the Louisiana Museum of Modern Art in Humlebaek, Denmark and at the Städtische Kunstsammlungen Chemnitz. My thanks go to Knud W. Jensen, who not only founded one of the world's most beautiful museums and built up one of Europe's most impressive public collections of Sam Francis' works, but who was also a close friend of his. I also wish to thank Helle Crenzien for her supportive cooperation in preparing this project. Susanne Anna, director of the Städtische Kunstsammlungen Chemnitz, and her curator Kerstin Drechsel must be credited with presenting the work of Sam Francis in former East Germany for the first time.

The exhibition would not have been possible without the assistance of Debra Burchett-Lere, who runs The Litho Shop in Santa Monica and is in charge of the Estate of Sam Francis. I am deeply indebted to her, particularly for her suggestion that we should adopt the beautifully expressive words THE SHADOW OF COLORS *from Sam Francis' writings for the title of this exhibition.*

This publication is intended not only to document the works exhibited, but also as a memorial dedicated to the artist who died in 1994. For this reason, I particularly welcome the texts contributed by his friends. To Peter Iden, Knud W. Jensen, Robert Shapazian, Kiki Kogelnik and Nico Delaive: thank you for sharing your personal memories. I also wish to thank Tilman Osterwold for spontaneously agreeing to contribute an essay and Pontus Hulten for so kindly permitting me to quote excerpts from his text in the 1993 Sam Francis Retrospective in Bonn.

The essay by Wieland Schmied, originally written for the Sam Francis exhibition he organized at the Kestner-Gesellschaft in Hanover, seemed to me to conjure up so vividly the period in which these works were created that I felt it deserved to be read again. I wish to thank him for allowing me to reprint it here. My thanks also go to Nancy Mozur, who ran The Litho Shop for Sam Francis for many years. The biography she has so painstakingly compiled is extremely detailed considering the relatively modest scope of the exhibition, and is intended as a tribute to Sam Francis.

Finally, I wish to thank Thomas N. Stemmle, who has ensured that this record of Sam Francis' work is not just a catalogue, but a beautiful book as well. Last, but not least, my special thanks go to the Wüstenrot Stiftung, without whose generous financial support this project could hardly have been realized.

INGRID MÖSSINGER

Louisiana visitors know Sam Francis as an old friend: since 1970 his large picture UNTITLED *(1956) has been hanging in the Giacometti Hall facing Lake Humlebaek. This major work was donated to the museum by the New Carlsberg Foundation.*

When the Museum Concert Hall was opened in 1976, Sam Francis spent several years working on its decoration. It was agreed that a six meter tall picture should be hung on the wall behind the open stretch of floor, and a picture nine meters long on the opposite wall. The pictures were several times replaced with others, but the measurements always remained the same. We had a number of such pictures on loan for quite some time, before we finally settled for RED II *(1979), which the Augustinus Foundation gave us as a present – in truth a welcome donation. We could not have done without this picture, which for years has formed an active and dynamic background for concerts, symposia and other activities; it is as if it lends some of its vitality to the performers, who in turn give a kind of new life to the picture by almost becoming integrated into it.*

From August 3 to October 29, 1995, there will be a Sam Francis exhibition in three rooms in the South Wing, comprising 44 works made between 1947 and 1977, that is to say up to the period of the Concert Hall pictures.

In 1957 Sam Francis went on his first journey around the world. Among the many places he visited, especially Japan made a deep impression on him. He was fascinated by Japanese traditions and in particular by Japanese calligraphy, which he transposed into his own artistic idiom. The late-summer exhibition of 44 works on paper will reflect this admiration for aspects of Japanese culture.

The exhibition will demonstrate several of the important phases in Sam Francis' oeuvre that have characterized the Louisiana collections. Let me suggest that you start your visit with the South Wing exhibition, then proceed to the Giacometti Hall, where you will find Sam Francis' large picture from 1956, his gouaches and his edge paintings - and finally end your journey through the Sam Francis universe by going to the Concert Hall to see the pictures hanging there.

We very much appreciate the cooperation of Ingrid Mössinger, art historian, who shortly before Sam Francis' death in the autumn of 1994 selected the 44 drawings which have never before been on show in Europe.

KNUD W. JENSEN

In the twenties, the founding director of the Städtische Kunstsammlungen Chemnitz, Friedrich Schreiber-Weigand, created a collection of leading contemporary artists such as Barlach, Heckel, Hofer, Kirchner, Kokoschka, Georg Kolbe, Lehmbruck, Munch, Nolde, Schmidt-Rottluff and others. The touring exhibitions of contemporary art he organized soon made the museum one of Germany's most highly regarded institutions of modern art. At the same time, however, the museum also collected seminal works from the Romantic era all the way back to the fifteenth century. The remarkable collection of some 25,000 prints and drawings includes works by Dürer and Cranach. A considerable quantity of drawings by Romantic artists complements the paintings by Friedrich, Carus and Dahl, paving the way towards the twentieth century and German Expressionism.

After the war, the museum continued to focus primarily on contemporary art, collecting and exhibiting works which reflected important developments in the history of art. Drawing on the tradition of private donations, this range has now been complemented by the acquisition of the Lühl collection, with its fine examples of western international art.

It is against this background that we have increasingly sought, in recent years, to present hitherto neglected milestones of art such as the German Art Informel represented by the early watercolors of Hans Hartung or a retrospective exhibition of graphic works by K.O. Götz.

We are therefore particularly delighted to be able to add an international dimension to these achievements with an exhibition of early watercolors and gouaches by Sam Francis. We wish to thank the Estate of Sam Francis and The Sam Francis Art Foundation for their generosity in lending the works, and Kerstin Drechsel, curator of our prints collection, for her organizational contribution.

SUSANNE ANNA

Sam in the Sea

KIKI KOGELNIK

When I first met Sam Francis at the Deux Magots café in the 50s, he was one of several "Americans in Paris" in a group that included Riopelle, Kimber Smith, Joan Mitchell and Shirley Jaffe. For me, fresh from the Vienna Academy, it was a very important encounter.

When Sam Francis visited me in Vienna the following year, I showed him a few artists' studios. He always took a great interest in what other artists, including younger artists, were doing. We visited Rainer, Mikl and Prachensky and he bought some of their works.

Sam was a poet. His love letters were either poems or gouaches. Blue gouaches. One of them hangs above my bed in New York:

All dreams are in us prophetic.

In everyday conversation, Sam always transcended banality. He had his head in the clouds, though he was by no means unrealistic – a rare mixture. He was a kind of Buddha-like figure who always seemed to be at the center of things because people simply gravitated towards him.

When Sam Francis had to stay in bed at the Tiefenau Hospital near Berne the following year, I once asked him why he didn't do some drawing. He said he had never done any. As a European artist, I was absolutely astonished. I brought him some ink and drawing pens, and he did his first drawings in hospital. I have one of them. They were a transcription of the forms he paints in color and they were intrinsically perfect right from the start.

Sam painted and drew from his world and whatever he broached became a part of this cosmos. In all my life, I have only met two such poetic artists; the other one was my Academy professor, Herbert Böckl. While we mortal artists are constantly struggling to make the next step, all Sam Francis had to do was open the tap and let it flow.

It is only now, having lived in America for so many years, that I understand how very much Sam was, essentially, a real American. He had a certain naivety, a love of open spaces, a generosity and idealism that have their origins in that country. His paintings and drawings speak of these things.

In memorian Sam Francis

KNUD W. JENSEN

As a young artist Sam Francis was influenced by the dominating art trend of the times, the Abstract Expressionism of the New York School. He was given an artistic idiom, almost as a present, but he applied it his own way. His breakthrough came with the large compositions from the years in Paris, 1950-57, when he learned to control the color on his large canvases: these brilliant, visionary pictures that demonstrate extreme ease, lyrical musicality and true artistic genius, were fully developed in the stimulating Paris atmosphere of the 50s. In those years Francis made many friends: Giacometti, Riopelle, Pontus Hulten, Franz Meyer and the legendary Arnold Rüdlinger, leader of Kunsthalle Basel, who made sure that Francis' pictures found their way into notable collections and later into the Kunstmuseum. The friendship between Francis and the two Swiss art lovers established a connection with New York and led to substantial purchases of American art for Kunstmuseum Basel. So Francis was famous in Europe much earlier than in the United States.

His art became radical: grey and white canvases, near-monochromatic, yet vibrating with color – first exhibited in 1952 at Nina Dausset's in Paris. He was always in complete control of the large-format surfaces: pictures such as *In Lovely Blueness* (after Hölderlin's poem), a major work from 1957, now in the Centre Pompidou; or the pictures in Basel Museum, or those owned by the well-known collectors Franz Meyer Senior in Zurich and Philippe Dotremont in Brussels, from whom Louisiana bought *Untitled* (1956) – a picture whose company I shall never grow tired of; it confirms Sam Francis' statement:

Color is the real substance for me, the real underlying thing which drawing and line are not.

The crucial element is always the active color: the many fields of color make up the picture surface, forms are created out of color, out of the pleasure inherent in the working process. It is pure painting without limitation. We come close to the point where the painting is generated and are entranced by the nature of color.

The 60s saw the emergence of the poetic ball paintings of great intensity of color – global forms afloat in the pictorial space, a kind of music of the spheres. Many of them were painted in Japan, perhaps inspired by the traditional lanterns or moonlike objects. From the mid-60s Sam Francis lived

in Los Angeles, but during his years of marriage with Mako Idemitsu he also owned a house and studio in Tokyo. The meeting with Japanese art, poetry and philosophy initiated a period of productivity which was stimulated by the cheerful, happy milieu created by the art dealer Kusuo Shimizu, whose Minami Gallery was also a meeting place for other American artists such as Jasper Johns and Robert Rauschenberg. Japanese artists, Arakawa among them, the critic Yoshiaki Tono, and the poet Makoto Ooka, also belong to the circle.

Sam Francis created a special milieu about himself; not consciously and wilfully, but gradually and quite naturally; he took a deep interest in people and liked to have them about him. His assistants had free and constant access to his Santa Monica house, built on the site where Charlie Chaplin had a summer house in the 20s. His graphics workshop, The Litho Shop, close to the huge studio, teemed with life. A corner office housed his publishing company, and people who were involved in some of his other activities and enterprises – windmills or alternative medicine – also met him there.

A relaxed West Coast attitude characterized the group, but occasionally Sam shut himself in his room to develop new themes in series of works. In the 70s it was his grid paintings, in which he confined his compositions in gridlike structures. These first attempts at controlling the free movement of the brush seemed heavy and stiff, and his friends were bewildered, for when an artist changes style the people about him tend to be *en garde*. But soon the style became much more free in large formats which barely show traces of the underlying grid structure, which eventually disappeared completely.

Gradually the artist regained control of the picture surface, and the result was a number of masterly works. A couple of them can be seen in the Louisiana Concert Hall, whose decoration Sam Francis spent much time on. Having tried out several upright-format versions (550 x 380 cm), with one horizontal pendant (300 x 800 cm) on the opposite wall, Francis finally selected two pictures which have now for 15 years juxtaposed their rich artistic vitality with the achievements of the various performers in the hall. In the very dense texture of the upright picture, *Big Red* (1979), numerous little flowering forms melt into one coherent surface, while the other, *Untitled* (1981-83), is open and free, a dynamic contrast to the dense picture on the opposite wall. They are proof that Sam Francis' could take command of a large room by purely painterly means and create a color milieu of great intensity. Jack Lang wanted Francis to decorate a large room at Le Grand Louvre, but the project came to nought.

I shall make a point of stressing that Francis presented the Louisiana Museum with the two Concert Hall pictures, along with many others, for instance gouaches from the Paris days and the Zen-inspired edge paintings from Tokyo, where color is confined to the picture borders. Again and again he used his own surroundings as a point of departure for new forms of painting.

He was extremely generous to his friends, and being with him was always a spirited dialogue. He was a good listener and his brief, but significant remarks inspired others and made them respond and thrive in his company. I respond and thrive in the company of his art: it has become part of my life.

9 November 1994

With Sam

PETER IDEN

Taking the elevator down from the upper floors to the hotel lobby means arriving suddenly. You do not see it coming. Its silent automation spills you out just as it swallowed you up; neither the person traveling down, nor the person waiting on the ground, is prepared for the meeting.

Meeting Sam Francis again in Bonn in February 1993 was a similar experience. Suddenly, there he was – a small, white-haired man, going on 70, marked by ill health, who seemed to have become more slender, more graceful, frail. Yet his presence is so charismatic, with a force so utterly independent of all physical frailty, that he exudes an air of enormous vitality. We have to get a bike for him here in Bonn, he says; he needs the exercise. Memories return of the times we cycled together along the path that skirts the Pacific beach by Santa Monica. I point out the cold rain and the heavy traffic here in Bonn. Sam gazes around the spacious hotel lobby: well, maybe he could do his cycling in here. Later, he did in fact put this to the management, but they would not entertain the idea, not even for this famous Californian.

Then, on the eve of a retrospective exhibition at the Kunst- und Ausstellungshalle der Bundesrepublik Deutschland, he was able to view some of his works again for the first time in many years. Pontus Hulten, a long-standing friend, had gathered them together in Bonn from all over the world. Once they leave the studio, paintings tend to lead a life of their own. Like children leaving home, they travel abroad and develop something akin to a personal fate. Some disappear without trace. For the artist who sees them again after many years, they recall the way his life was when he painted them.

Take the paintings of the 50s. Following an accident with lasting repercussions (he had enlisted in the Army Air Corps in 1943 and crashed on a training flight), he spent the 50s in Paris with the painter Muriel Goodwin, whom he married there. They stayed at the Hôtel de Seine, later moving to a small studio on the Boulevard Arago in Montparnasse. It was here that he painted those early works flooded with light, monochrome, multilayered canvases with color as their only theme. They were first shown at the Galerie du Dragon, Paris, in 1952. Here was a kind of painting unprecedented in its radicality, imbued with all the freedom and lightness for which Giorgione was once acclaimed. Here was painting pursued as a poetic adventure in quest of something entirely new: not seeking to portray the world, but to set an emphatic counterpoint, lending each picture a reality of its own – provocative, wonderfully courageous, enigmatic, magical. He smiles on seeing them again – and on seeing himself, in the paintings, as he once was.

The spectator accompanying him finds yet another story, his own, reflected in these paintings, particularly the later works – in the conflict of order and spontaneity on these huge canvases, in the sheer enthusiasm of the brushstroke and the characterization of color. They recall a past affection, the early appeal of this modernism, this way of seeing the world that succeeds, as Arnold Gehlen (in his *Zeit-Bilder*) mused, in "bringing art within reach of the talent of our hearts". It is a possibility rumored to be exhausted; its demise is often cited as the century draws to a close.

But what else do we have? Where do we go from here?

A room with a view of the Rhine cloaked in a grey veil of rain. It is late in the afternoon. Sam Francis visits the new German Bundestag building designed by Günter Behnisch, for which he is considering painting a mural. The president of the Bundestag welcomes him there. She is nervous; Rita Süssmuth has other things on her mind. Sam Francis soon breaks the ice, however, and before long their conversation has turned to German literature and philosophy, to the mysticism of Hildegard von Bingen (whose writings he edited in California) and to the illness that has weakened him.

Before we go. In my paintings, he says, the ephemeral dreams our dream of the duration of the moment. "But you see, this duration: you find it only in art." Nothing else lasts.

Working in the Dark

ROBERT SHAPAZIAN

In the course of my task as director of the book publishing company owned by Sam Francis, he and I would speak together frequently. Everytime I heard his voice, my spirit would jump, for I knew I was about to have another inspiring conversation with my dear friend, a conversation full of great humor, great ideas, enthusiasm, affection, dreaming, and passion for everything we discussed. When he called one summer afternoon, his voice was unusually soft and cautious, as though he were going to tell me a secret. "Robert, you know, in a few days I'll be getting some drawings that have been in storage in my Tokyo studio for years. They're very special. Very dark. Black drawings. You know, things that I haven't shown much, and that people don't know very well, that they don't understand. They're very personal and important to me. I want you to see them."

Sam was inviting me to see work that he considered intensely private and deeply interior. But, when we viewed the drawings, I found them mysterious and full of paradox. Here were dark studies in pools of black ink made by this supreme master of brilliant color, a man who searched the world for rare pigments, who ground and mixed them like an alchemist, who created beautiful shades that were uniquely his. What were these dark works? Why the decision to pull back from color into this black essence? My first reaction was puzzled disappointment.

As I looked at the paintings, however, what my rational mind questioned, my feelings and intuition did not. Yes, they were black designs on white paper, with infrequent touches of color. But, each was exuberant and gorgeous, with all the intensity and energy that I associated with Sam's full spectrum of color. My eyes saw black, but I felt a complete range of brilliance as well as darkness. Even the most densely painted studies contained great light and clarity. My knowledge of Sam's coloristic works gave me insight into these dark drawings. Each mode revealed something about the other.

So, these works were not less, because of their insistence on black. They were, nevertheless, a conspicuous renunciation of the variety of color and everything unique to it. In these monochromes, Sam seemed to retreat from, let us say, the florid beauty of the world into an extremely interior place of essence and concentration. We might call it the place of in-sight. I understood this after discovering these lines written by him in one of his many notebooks:

Insight is in the dark
all insights are dark

What does this mean? Insight grows out of darkness, out of prior obscurity. Insight rises from depth towards illumination. But insight also increases depth and profundity, opening a new terrain of mystery. One can go on and on, trying to unravel this paradox about the eternal and creative relationship between opposites of all kinds. Sam believed the truth of this paradox completely.

Thinking more about his work, I realized that black images occur throughout his career. They are a constant, like the essential interior Being of the artist, himself. Set against them is the abundant variety of all the coloristic works which, as they change in shape and hue, always relate to the dark constant. This is true even during the early 1950s, when Sam Francis made the large paintings that resemble a translucent and airy atmosphere of uniform white, or blue, or light orange. At the same, he was making small works on paper in clotted black, but identical to the colored canvases in the overall application of pigment. The small studies actually anticipate both the masses of black paint and large areas of high color that dominate the large paintings several years later.

In the artist's notebooks, we find other paradoxical statements about the relationship of darkness to the appearance of lightness and air:

an increase in light
gives an increase in darkness

This painting gets more airy as it gets darker

Color is born
of the interpretation
of light and dark.

Working in the Dark

The relationship is clear: darkness is a creative companion to its opposite; the spareness of black engenders the abundant beauty of colors. Wholeness is the willingness to do it all.

I am attempting to tell you something about the special significance of "working in the dark", or "working with the dark", as it relates to the deepest artistic and personal exploration of Sam Francis. Thinking about him, I remembered that nearly all of his self-portraits are painted, etched, or

lithographed in black inks. A few exist in monochromatic red or blue, but their solid color is like the singularity of black. This is a very simple but clear point: For Sam Francis, black is the material and the tool to examine, explore, and fashion the image of himself.

This is especially apparent in the large group of graphic self-portraits he made during the 1970s, that he called "Anima Prints". At the time, Sam was engaged in Jungian analysis which provided concepts to aid his exploration of his personal and artistic being. In Jungian theory, the anima is the feminine principle which men must explore in order to augment their primary and external male persona. In men, the anima is hidden, internal, unconscious. It is some times called the "not-I". Associated with emotion, intuition, and the creativity, it resides in womb-like and pregnant interior darkness. Anima is the archetype of life itself. Most important, Jung defined it as a psychic image. In this regard, two phrases in the notebooks of Sam Francis are especially relevant:

My consciousness is an image.
Everything of which I am conscious is image.
All my experience is psychic.

The Anima Prints are, therefore, an index, or guide, to the relationship Sam Francis forged between monochromatic black, the darkness of the hidden self, and the creation of his psychic and visual image. It is no wonder that studies in black exist throughout his career, always penetrating, examining, and pre-figuring ideas and forms that later blossom into full color, form, and scale.

The idea of relationship was always crucial to Sam: the relationship between dark and light, soul and matter, life and death, and an infinity of possible combinations. As he writes in his notebooks, "Depth of All". For him, relations are never static, fixed, or resolved. Instead, they are potent, even chaotic, and pregnant with an infinite deepness of searching, possibility, and creativity.

Why do we say "shades" of colors?
– shadows of colors –
Who has seen pure white?

His preferred term "shadow" means the interplay and integration of light and dark, of substance and immateriality. But "shadow" also means a reflection – a thing seeing itself. Were we discussing this with Sam Francis, I know he would push our definition of "reflection" to include the meanings of thought, introspection and questioning. So, we are again in that world so characteristic of him, where everything is elusive yet exuberantly full. There is no pure white, no pure black. They are mixed and reciprocal, containing the whole spectrum of color and possibility. At the beginning of my remarks, I said that his black drawings seemed to me just as florid and gorgeous as his works in color. When you can experience this for yourself, you experience something essential about Sam's great creativity: his ability to express in a work of art his most deep, elusive, and mysterious perceptions of himself and reality.

We have heard many times the saying that it takes courage to be creative. Why is this? Because, creation is the making of something out of nothing, where nothing existed before. It is "Working in the Dark". One must have fearlessness and self-confidence to work in the dark, for one is most vulnerable there.But, great humility, great trust, and an abiding love of creation, in all its aspects, also must be present in anyone who gives himself entirely to the deepest creative life. I can personally attest, this is absolutely the kind of man that Sam Francis was.

Venice, California, January 1995

I've had a Dream of an Ocean[1]

INGRID MÖSSINGER

Sam Francis initially began to paint during the interminable hospitalization that followed his plane crash as a US fighter pilot. In his first paintings from this 1944-1947 period when he was bed-bound and virtually immobile, we can still discern the influence of such artists as Picasso and Klee. On being discharged from hospital, he seems to have found his own style almost eruptively, as the earliest works in the exhibition *The Shadow of Colors* indicate. It is almost as though his liberation from the strictures of the plastercast had also liberated his means of expression.

Sam Francis initially spent some time convalescing by the sea in California, where he created *California Grey Coast* (1947, p. 21). One might expect a convalescent to paint seascapes as seen from the shore. Sam Francis does not. He gives us a narrow strip of foaming grey water from a bird's eye view, as seen not only from out at sea, but also from above. Here, we already find evidence of the aspect that makes the work of Sam Francis so unique: its unexpected viewpoint. What is more, as we can see in this early work, he blends dreamlike memory (flying over the sea) with actual reality (time spent on the coast). The result is a very specific form of abstraction imbued with realism that lends all Sam Francis' works an unsettling sense of floating suspension. What is more, even the early images portray a sectional view, giving the impression of a detail microscopically enlarged and alienating the whole. When Sam Francis compounds this effect with a bird's eye viewpoint, the resulting superimposition of distance and proximity, far and near, tends to catch the spectator unawares. In this way, he creates coastal images that could just as easily be Japanese calligraphic signs (p. 27, 35). Huge waves (p. 39) seem to be observed through a porthole at the level of the waterline, lines appear to suggest a strip of coast or the branch of a tree (p. 33, 41) and semicircular areas might be sunrises or sunsets (p. 51).

Nature, especially the mutable elements water and air, plays an important role in the visual language of this Californian artist. His technique of pushing color forms to the extreme upper or lower edge (p. 37) could well have something to do with his experience of water, air and space (for which he paid so dearly in his plane crash). As in his paintings, the distinctions between above and below, far and near, are blurred by the constant displacement and distortion of a horizon in motion. For this reason, neither the strongly colored paintings, nor the predominantly dark works in the exhibition, convey a sense of calm tranquility. Even the brushwork, as in many of the larger paintings, is aqueous and fluid (p. 65, 73). Just beneath the surface of the darkness, a groundswell of color keeps the paintings in motion. It is with these "shadows" of colors that Sam Francis succeeds in giving even black the consistency of water or air (p. 57).

I like to fly, to soar, to float like a cloud [2]

1, 2 Sam Francis quoted in:
Peter Selz, SAM FRANCIS, *New York, 1982, p. 13/14.*

13

Sam Francis – Black Drawings

TILMAN OSTERWOLD

When I think of Sam Francis, I think of color. Rich color. A brimming cornucopia of color that spills out over his paintings, irrepressible and unchecked. Color as a seemingly endless and absolute state.

The "Black Drawings", most of them small, are like a minimalistic counterpoint within the oeuvre of Sam Francis. The bright expanses of his colorful world are transformed into black and white, reduced and introverted. This effect is in keeping with his unorthodox approach to composition – far removed from the almost "cosmic" whirl of open color fields. In his "Black Drawings", Sam Francis draws the composition from the sheet format towards the inside, as though the paintings were magnetically centred within its rectangular boundaries. The paper itself becomes the theme of the black and white painting; an image displaced, bisected and overflowing amidst the coordinates of left/right/top/bottom/horizontal/vertical. The boundaries of the black shapes are widened by occasional splashes that seem to come from the movement of the artist. Diagonals knock the spatial equilibrium of these works out of kilter. A single brushstroke becomes a strong and simultaneously dissolving movement, empty spaces become active, painted areas dissolve, consolidate, become transparent, break down into interactive areas and seek, from there, the stability of the whole.

The irresistible sense of movement evident elsewhere in the work of Sam Francis seems to be held in check in his "Black Drawings". They move rhythmically through his entire oeuvre from the late 40s onwards. (The spirit of Jackson Pollock in the black dripping does not develop freely, but seems to have been halted by Sam Francis and contained within the consciousness of the painting's boundaries.) In his "Black Drawings" Sam Francis projects the painting as a provisional space, as a fictitious place for concepts in motion, coming and going, tense and calm, passing by, moving on, concepts that can be bound.

His "Black Drawings" breathe timelessness. This is as true of the individual work as it is of the oeuvre in its entirety. (If they were undated, it would be difficult to ascertain where they fit in to the oeuvre of Sam Francis.) Open, impenetrable spaces are created in which all possible intermediate shades of white and black emerge.

It would be an interesting experiment to consider these "Black Drawings" both at a distance and close up, "blind" as it were. Many paintings, especially the large and colorful, fluid "cosmic" compositions of Sam Francis, defy memory and go beyond an overall sense of remembrance. The "Black Drawings" seem to have been created out of some vague memory committed to paper and they give the impression of seeking to return to the conscious chiaroscuro of the mind where they can be called up at any time, found and observed by the mind's eye.

Rereading Notes on Sam Francis

WIELAND SCHMIED

I

Born on American's western seaboard, near San Francisco, city of a hundred hills, with its bays and its Golden Gate Bridge, the city in the West that is the continent's gateway to the East. A childhood spent in California, between the green of gardens, the yellow of peaches and the color of oranges, between white houses and a high blue sky, beside the deep blue of the nearby Pacific Ocean. After high school, Sam Francis, a professor's son, began studying medicine and psychology.

Then the war came. While still a student, he enlisted as a fighter pilot. He found freedom above the clouds, defying gravity, leaving the material world far beneath him. Before he had even seen active service, Sam Francis crashed on a training flight over the Arizona desert. He survived with serious back injuries and spent the next two years almost immobile in a hospital bed, reading avidly, watching the sun dance as it streamed through the window, casting pools of light and shadow on the walls.

He decided to become a painter. It was a way of escaping from himself, a way of finding himself. On leaving hospital, he entered the School of Fine Arts in San Francisco, later going on to study Art History at the University of California. In 1950, he went to Paris where he joined the small colony of young avantgarde American painters grouped around Jean-Paul Riopelle. He stayed there for almost ten years.

It was the pioneering age of a new painting, the age of what Michel Tapié called *un art autre* and others called "action painting" It was the heroic age of a dynamic, vital, spontaneous painting that made a major American contribution to the history of art. It was the time when some young and hitherto unknown talents made their breakthrough. Painters now in their forties or fifties, respected figures on the international art scene (however much they personally may eschew and even disdain that same scene). Meantime, the next generation is already waiting in the wings and the generation beyond that is gathering arms for a new revolution.

After the pioneering years in Paris came years of universal acclaim. Sam Francis began a restlessly nomadic life that was to lead him to Mexico, Japan, Thailand and India; twice around the world. He was clearly fascinated by the visual world and by the forms and colors of exotic countries.

He absorbed the mood and atmosphere of Mexico just as he had previously absorbed the southern light of Provence during his stay in Aix in 1952. It was the Far East, however, that affected him most profoundly of all, and it was the spirit of the Orient to which he gave himself most fully. Meditation, to which he was already receptive, joined his sense of spontaneity. Japanese toys and kimonos, dragons and puppets filled his studios in New York, Tokyo, Paris, Berne, Santa Barbara. His reaction to growing fame was one of conscious withdrawal and voluntary retirement, from which his strong personality broke out time and time again onto new paths, in search of new adventures.

II

In many ways, Sam Francis would appear to be the epitome of the American artist. So it may be worth our while dwelling for a moment on this concept. Unlike the French artist, of whom we expect some expression of heightened and concentrated national characteristics, the American artist is primarily the antithesis of all we associate with American life; he is a man who confronts and challenges his surroundings. A man who breaks out of a world virtually void of history and obsessed with the here-and-now, to seek his origins in the Old World. Though cited to the point of hackneyed cliché, the well-worn title of the composition "An American in Paris" actually has rather more to say than one might at first surmise, and it succintly sums up the artistic situation of the day.

This meeting of minds – American and European – has often borne fruit, most notably in the literary achievements of the Lost Generation who arrived in Paris in the wake of the first world war: Ernest Hemingway, Ezra Pound, F. Scott Fitzgerald and others who came and went at the home of Gertrude Stein and her brother Leo. They belonged to the second generation of American writers – the first being that of Walt Whitman – consciously to break with the conventions of European tradition, taking as their yardstick the lack of any measure, adopting as their most distinctive trait the liberating gesture of their impetuosity. This second generation, rediscovering Europe, refined wildness and cultivated spontaneity, all the while remaining American in their stance of protest, in their volatility, in the passion with which they burned themselves out, and later, in their eager reception of Far Eastern thought.

The situation of the Lost Generation after the first world war was comparable to that of the American artists' colony in Paris after the second world war. These painters, too, belong to a "second generation". The generation before

them – Mark Tobey and Mark Rothko, Arshile Gorky and Willem de Kooning, Franz Kline and Clyfford Still, Adolph Gottlieb and Barnett Newman – had already found its own distinctively American style. The work of the immigrants Gorky and de Kooning is as typical of that generation as the gigantic formats of their American-born counterparts Kline, Still, Gottlieb and Newman. Another characteristic trait of this "second generation" has also been noted: the painter stands in front of the canvas or inclined over it as though confronting an enemy and preparing for a harsh and merciless struggle. This is no dialogue; this is a battleground. The canvas is the void, chaotic and threatening, to be filled by the – invariably subjective – order of art. The dynamics filling the canvas involve a profoundly concentrated and almost painful painterly process, traces of which are recorded in the painting itself. This is certainly true of Jackson Pollock and Riopelle, far more so than it is of Sam Francis. Yet we shall never quite grasp the full meaning of its outward appearance if we do not bear in mind its inherent aspect of courage and adventure and the artist's underlying quest for spiritual experience through the constant willingness to address an unknown and unconquered world and to give up an existing and hard-won stance.

Sam Francis' role in this American artists' colony in Paris is not dissimilar to the role played by Hemingway thirty years before. Something akin to a personal myth built up around both of them. Both were cosmopolitans who adapted with ease to constantly changing surroundings and new locations. What one might at first be tempted to dismiss as inconsistency turns out to be the distinctive trait of a certain type of artist for whom the world is a natural place of fulfilment and development in which inner space is reflected in external circumstances. Attempts have been made to explain the large formats chosen by Sam Francis and other American artists by pointing out the sweeping grandeur of the American landscape. It can also be explained, more easily, as a gesture of inner grandeur that needs space to develop and does not end at the edge of the painting, but continues far beyond. Sam Francis paints everything and, because of this, his paintings could just as easily be ten times the size they are and still be a mere detail of the whole, evocative in its artistic density. Again, not unlike Hemingway, his is a cosmopolitan worldliness contrasted by an almost timid avoidance of increasing public interest. (We may at times find it helpful to adopt Plutarch's maxim and attempt to make the contours of one form visible against the background of another, in order to delineate mutual and divergent aspects of individuality and type.) These are

fitting traits for an artist who has suffered many injuries and faced many hazards, who has gone through many things of which he does not speak, preferring to leave them unsaid, who loves the world and does not shrink from danger, who gambles what he has won and in the end is vulnerable, who rejects the security of a system, a credo, a fixed *weltanschauung*.

III

Sam Francis' art, at its finest a felicitous blend of the American sense of space and European painterly tradition – late Monet, early Matisse, mature Bonnard – follows on from the work of Clyfford Still, whose laconic surface detail becomes the subject of the painting itself: the image here, as Franz Meyer once put it, is "part of a continuum within which the frame merely delineates an otherwise unprivileged area". We may regard that as a manifestation of the need to "relate the visual order in the painting to an unlimited reality".

The movement that produced the forms we find in the earliest known paintings by Sam Francis, dating from 1949 and 1950, goes beyond the edge of the painting. The forms themselves often appear "cropped". What begins as a vague and indeterminate world of limited color fields that seem to hover or float on the surface of the painting is eventually pushed to the edge of the painting where it appears to become completely detached, teetering on the brink, floating, dissolving. The center of the painting remains almost completely empty. At least, no distinct forms are immediately recognizable. It is only gradually that one discerns, against the almost entirely monochrome, often white or nearly colorless ground, forms that have hardly any independent life and to which, properly speaking, we ought to refer as structure, as an organizational principle of space. These structures come alive only here and there at the edges where they tentatively adopt color and take on an independent formal existence.

In the years that followed, these forms gradually began to fill with color, slowly at first and then with increasing intensity, initially in broken and clouded colors of an earthy, loamy hue, then distinctively purer, more brilliantly luminous. At the same time, the brushwork becomes more fluent and the forms begin to flow together, albeit without ever actually converging and without blurring the contours. In this way, the forms, no longer identical with the ground of the painting, but hovering above it, are once more interwoven to an overall structure which, again, like a cropped detail, refers to the structure of the world as it appears.

Around 1954, after his monochrome period, Sam Francis turns to full and gorgeous color, adding orange to his blues and greens; it is the juxtaposition of other mutually enhancing and heightening colors that now determines the mood of his works. At this point, form is still the predominant feature: the colors are divided into individual groups of forms, whereby one group of forms may appear as a detail, as a window, within another. The colors have no influence on the formal structure, the forms themselves are linearly bounded, almost as though the color had been added as an afterthought.

A decisive turning point is heralded in 1955 with the advent of black in a twofold function, both as color and as counterpoint to color, so that it covers other colors and only occasionally allows them to flare up. From here on, color takes the lead; the forms no longer appear to be definitive, but constantly recreated and restructured by the spontaneity of the brushwork. Another and perhaps equally important feature of this change is the sense of upward movement that now begins to dominate the entire visual structure, leaving beneath it on the canvas an ever larger white space marked only occasionally by increasingly forced brushstrokes and emerging as an image in itself. This emphasizes the transitory nature of all that appears in the image. The artist's treatment of the white surface as an essential part of the whole is a clear indication of his concern with oriental thought and the eastern concept of omission as a stylistic principle.

While the white ground emphasizes the meditative aspect in the work of Sam Francis (the colors often sprawl over the surface, disappearing somewhere beyond the painting itself), the flowing brushstrokes and traces of flung paint heighten the sense of spontaneity and dynamism involved in the act of painting. Let there be no mistake: these dribbling, running drips, these splashes and daubs of paint flung across the canvas like transient "pictorial thoughts" are by no means as spontaneous as they seem at first glance; nor are they inevitable traces of the painterly process. On the contrary, they are deliberately applied, highly stylized "spontaneity" in much the same way that Hemingway's bar talk is not merely reality transcribed, but a distilled and stylized simplicity that is the product of a carefully nurtured artistic process.

In 1958, a new transitional period begins (it has also been interpreted as a crisis) which may have been intended to offset a pictorial form already perceived as "too beautiful, too perfect": in 1960, the pictorial structure clarifies again and as the provisional last period, we find a reduction to blue (occasionally supported by green, rarely contrasted by red); as in the early "monochrome period" we can now speak of the "blue" period: blue circles, spirals, spheres or amorphous shapes surround the empty, bluish center of the picture, occasionally forming a strangely static cross, but more often appearing as the fluid detail of an all-embracing movement.

IV

Few "abstract" artists make such evocative reference to nature as Sam Francis. Each and every one of his paintings is bursting with optical experience and eidetic perception, steeped in the visibility of the world. It is probably wrong to talk of his paintings in terms of "what they remind us of". It is, after all, the distinguishing feature of his painting that we do not sense the suggestion of a certain landscape somewhere just out of reach beyond the canvas. The transformation is more profound and more far-reaching; it is never a mere "transcription" of nature. What appears in the painting is a visual juxtaposition of optical impressions gleaned in very different places under very different circum stances which now form a new visual unity structured in accordance with their immanent qualities, ordered according to their inherent character.

Perhaps one might venture to say that if the world, in geographic terms, is present in these images, then it is a world seen from a great height, from a stratospheric flight or some other aircraft. Sam Francis paints the earth as seen from the sky, and the sky as seen from the sky. These are aerial pictures, cartographic transcriptions, maps of entire continents (as in *Two Worlds*) the old, linked with the African, and the new, divided by the Caribbean Sea, linked by a blossoming branch.

The experience of foreign lands, with a cherry-blossom form suggesting an island, for example, is strongest in the paintings of the period 1957-58 (*Meaningless Gesture, Study for Moby Dick, Whiteness of the Whale, Round the World, Towards Disappearance*). The early works, by contrast, tended to conjure up thoughts of clouds, of mist rising to envelop land, water, sea, light and even fate itself, seeming to draw them to a far-off distance. In these early works, the objective interpretation is dismissed for ever, allowing the entire earth to rise into the field of vision, redeemed, in pure colors.

The words of the Japanese poet Yoshiaki Tono describe the metamorphosis of the exterior world in the works of Sam Francis, so compellingly evocative in their formal abstraction that "invisible blossoms fall from Sam's blue".

It is not only the exterior world that appears transformed in his oeuvre. The human aspect is also present – though not in equal measure in all his periods. Whereas the visual experience of the exterior world dominated in the period 1954-60, it is the interior space, the imagined conscious world, that appears now and again in the blue period; early cell-like structures later become isolated, seemingly lost organs robbed of their functional link with the whole. We may venture to assert that these paintings reflect something of the human suffering of our age, which is in general more physically than spiritually determined.

This is not so simple to prove, but we can look for clues in some of the titles he gave to his lithographs of 1960, the year of a serious illness: *Blue Bloodstone, Happy Deathstone, Snake on the Stone, Happy Deathprints, Damned Clips, Coldest Stone.* These titles indicate a stoic (and thoroughly American) attitude to death and pain, as something to be faced with courage and without any noticeable expression of feeling. But how does that come across in the picture? Though it would be too direct and misleading to say that memory, associations of bleeding, damaged kidneys, burst blood vessels, ruptured veins are actually visible in the painting, we can indeed perceive something of the formal structure of human organs (albeit admittedly more as theme than as object) and it cannot be denied that we have some impression of a world out of joint, injured and sick. Even the blue in many of the paintings from this period appears to be blood. The green that once grew from the soil to bear blossoms between earth and heaven now seems poisonous, bilious, evil. In the blue-toned ground of the canvas and foliage we discern a ramified nervous system in which, time and time again, we perceive in an elongated, oval form, or in the course of a line, what seems to be a hesitation, a withdrawal, a recoiling, as though something had suddenly been touched to the quick.

Is this merely a subjective interpretation? It is still too early to decide. What we have here is certainly a visual experience unprecedented in the work of any modern abstract artist, with gestures and silences of a quality we do not find in the work of Hartung or Sonderborg, Pollock or Poliakoff. It will be a very long time indeed before we have developed a vocabulary appropriate to this visual world and before we can say just how much it has affected us, and how profoundly.

Quoted from the catalogue of the SAM FRANCIS *exhibition at the Kestnergesellschaft, Hanover, in 1962/63*

The Inside of Angels

The self-evident image

The paintings of Sam Francis possess an extraordinary quality that is very difficult indeed to express in words. There is something natural and self-evident about them for reasons that seem to defy explanation. There is a sense of wholeness in his oeuvre, a total interaction and complete integration of the individual elements that make up these paintings: size, color, scale etc. They are as inexplicable as perfection itself. These paintings radiate an intelligence that asks no questions, but expresses a certain equilibrium and exudes a sense of peace. There is always a certain distance between the universe in these paintings and the rest of the world. It may be for this reason that his paintings do not enjoy the same popularity as those of other artists whose works are more extroverted but less artistocratic in their stance. The word "aristocratic" is used here in its purest sense.

This *noli me tangere* and the self-evident nature of the work emerge directly from the work itself and have nothing to do with its presentation.

Sam Francis has confirmed that there are no sketches for his paintings. "A sketch has to be spontaneous. I am not doing preparatory sketches for a particular painting, I am preparing myself … Becoming aware of the (my) mind in a context that can lead to a painting. A painting can appear out of the unknown, A painting can be started according to a way of working."

Size and scale

In the paintings of Sam Francis, the concept of scale plays a predominant role and his handling of scale is highly distinctive. This is another reason why his paintings generally look so different from the works of other artists of his generation. It is very difficult to determine just what it is that is so different about this element of scale. His scale is certainly larger. Larger in the sense that the figurations we see on the surface appear to be observed from a great distance, from high above or from far away. From high above is more precise. This another reason why his paintings look so strange when they are shown alongside the works of other artists. It is not only his sense of scale and treatment of it that is different. Nor do we always look at things in the usual and habitual horizontal way. We have the feeling that we are looking at something from very far away or from very close

up, without a definitive dimension. What is the scale of the void? Sam Francis has often said that there are different kinds of voids. "There are all kinds." He talks about infinity in a way that is reminiscent of the 18th century Swedish philosopher Emanuel Swedenborg, who collected different kinds of silence. In London, Swedenborg kept a collection of bowls containing what he saw as representing variations of silence: "The silence between spouses, the silence of a calm lake in a forest, the silence over the China Sea etc."

There is also the infinity of movement perceived by the eye of the beholder, endlessly calling into question the surface of the painting and driven endlessly further and further from one form of configuration to another and yet another, driven on by the dynamic force of the energy hidden in the forms and figurations.

If we imagine the brush as a sword, then we should certainly not regard the canvas as the enemy to be killed. It is the very act of fencing, as it were, that is important. It is not death that is at issue here, but birth.

In fencing, everything depends on rapid and correct reactions to each new situation in a constant continuity of events. Each situation is different. Repetition is not good. It can even be dangerous.

Sam Francis has described his brush as the harpoon with which Ahab hunted Moby Dick. That is an enormous challenge. It is an astonishing idea. Here we have the infinity of deep black, dark grey or almost white cloud formations, beating like the heart of some gigantic creature of which we can see only a small part of the skin, such as a framed rectangle of blue, a piece of the forehead.

Sam was once asked what these paintings were meant to signify. He replied: "They are the inside of angels."

SAM FRANCIS,
Kunst- und Ausstellungshalle der BRD 1993, p. 22, 33/34

Art is at the Heart of the Matter

NICO DELAIVE

Eight years ago I was first introduced to Sam Francis by one of the artists I represent, Walasse Ting. It was the beginning of a very warm and intense friendship. Every two months I met Sam in California where he had several studios at the shore in Point Reyes, Palo Alto and Santa Monica. Sam was a very strong personality, often referred to as "the Lion". When looking at him you wouldn't say so, but I've never met anyone so determined in his actions.

He had a passionate poetic mind, which occurred to his surroundings and the public in his sparkling radiant works of art. Often he wrote me and his letters contained beautiful poems. One which is very typical often comes into my mind:

Art is at the heart of the matter.

We also had a great deal of fun and good laughs. And that's why I will always remember him and through his paintings this thought will be kept alive.

California Grey Coast, Berkeley 1947
Gouache on paper
21 ⅛ x 16 ⅝ inches
signed, dated, titled by artist
SF47-002

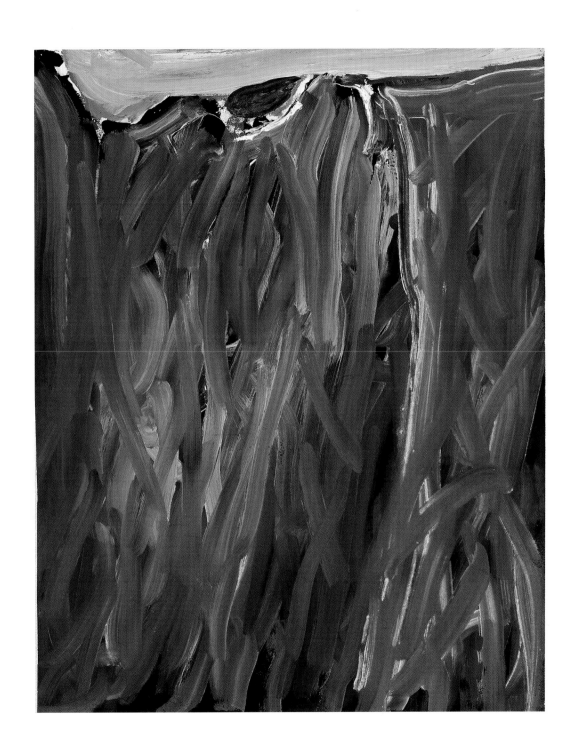

Untitled, 1948-50
Watercolor on paper
7 1/4 x 12 1/4 inches
signed S. Francis, lower right
dated on the back 1950
SF48-001 (SF50-84)

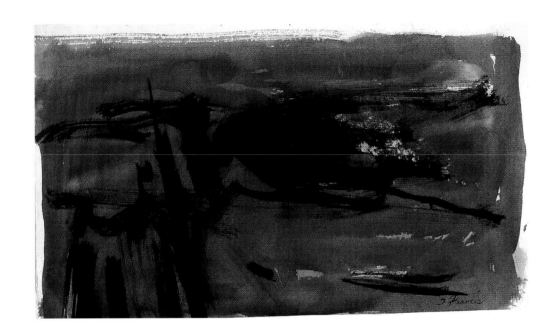

Head, Berkeley 1948
Ink on paper
17 3/4 x 14 7/8 inches
signed, dated by artist
SF48-010

my starting point has no dimension

neither in time
neither in color
space
or death
but is a unified
even wave with intensity

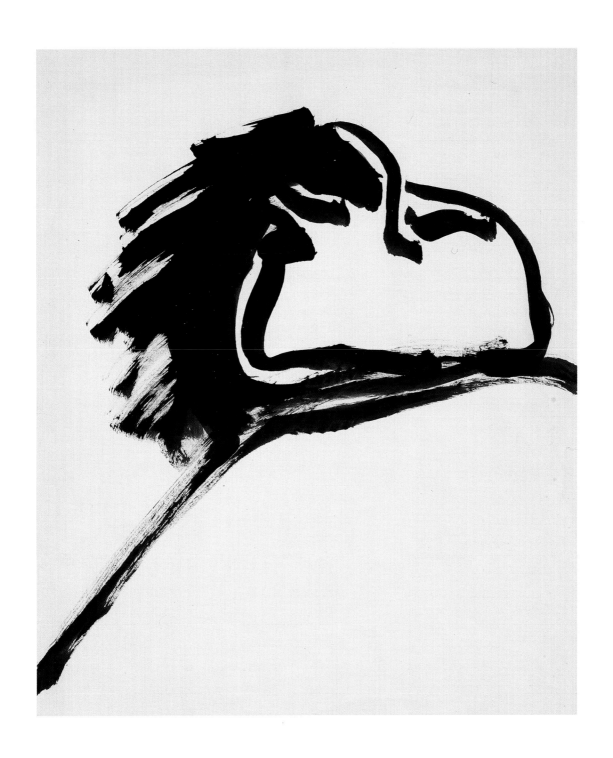

Untitled, 1948
Ink on paper
18 x 12 inches
signed with initials S. F., dated
SF48-015

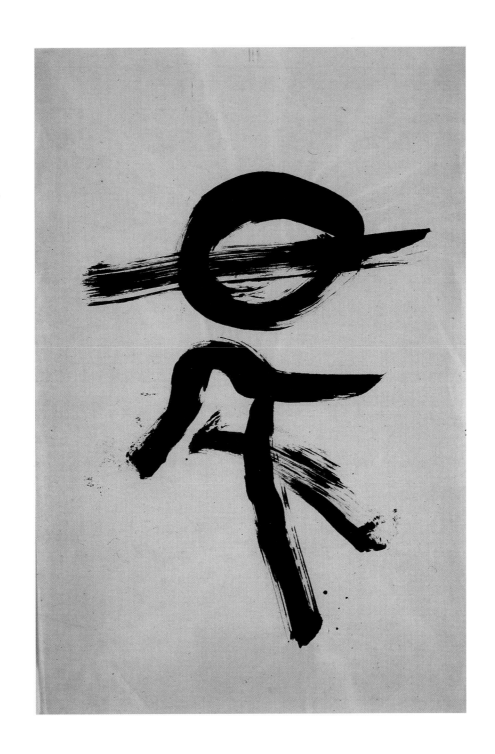

Untitled, c. 1948-49
Ink on paper
17 3/4 x 12 inches
unsigned, undated
SF48-016

Darkness is a principal attribute of Blue

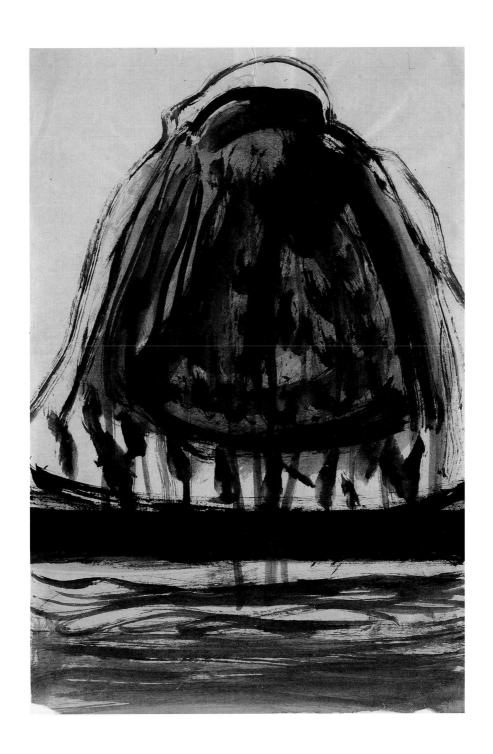

Untitled, 1948
Ink on paper
12 ³/₄ x 9 ½ inches
unsigned, dated
SF48-017

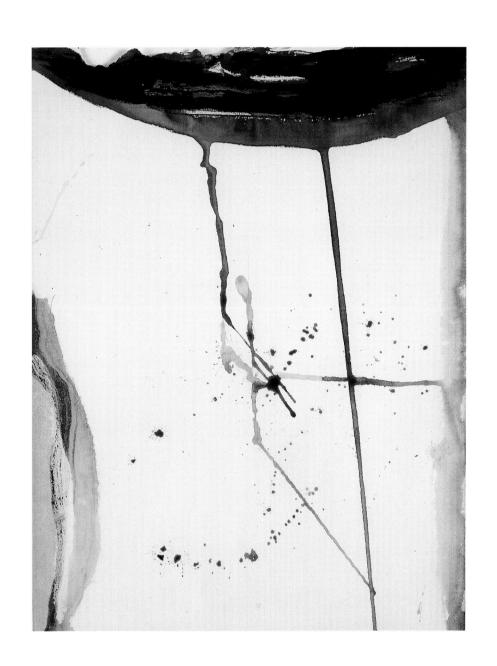

Untitled, San Francisco 1949
Ink on paper
14 ½ x 11 ⅞ inches
signed, dated
SF49-001

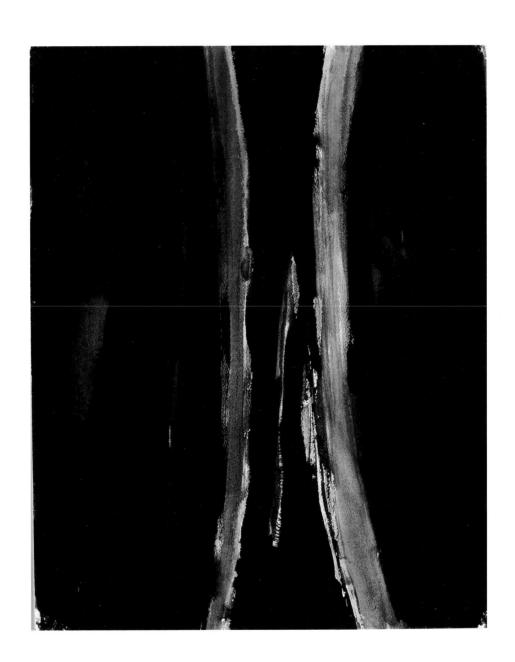

Untitled, Berkeley 1949
Ink on paper
18 $\frac{7}{8}$ x 12 $\frac{1}{2}$ inches
signed, dated
SF49-003

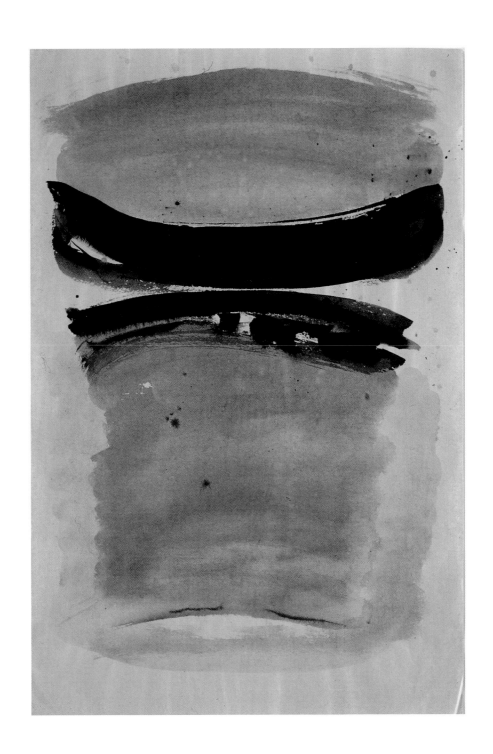

Untitled, Berkeley 1949
Ink on paper
21 ½ x 17 inches
signed, dated
SF49-017

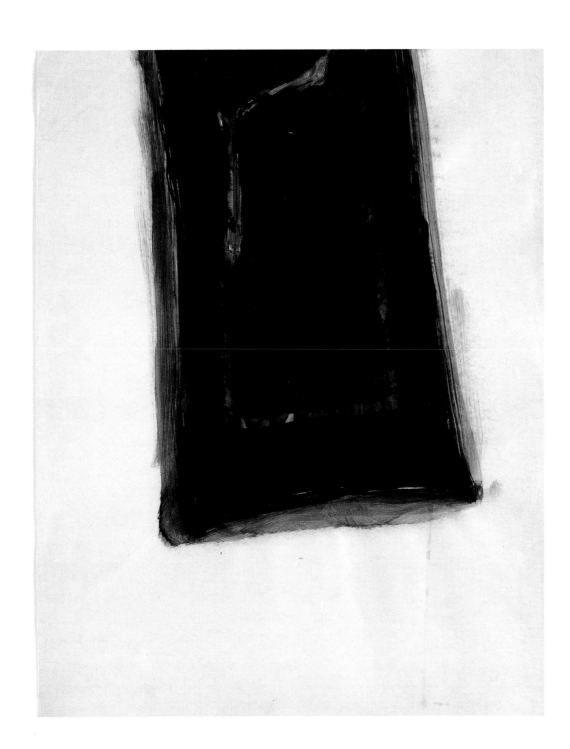

Untitled, San Francisco 1949
Ink on paper
15 x 17 ³/₄ inches
signed, dated
SF49-040

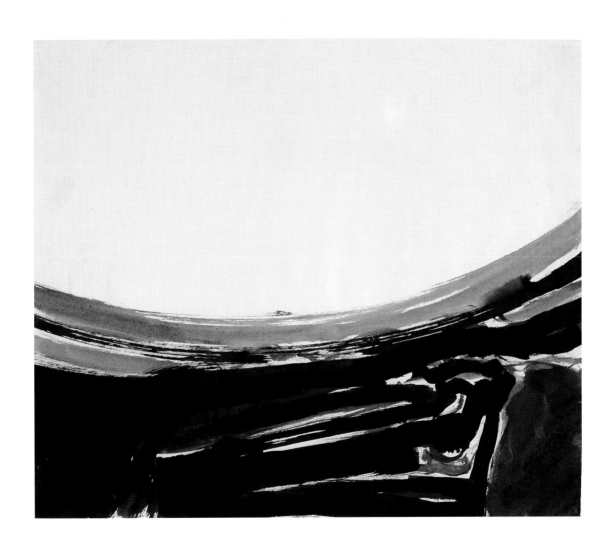

Untitled, 1949
Ink on paper
17 ³/₄ x 15 inches
signed with initials S.F., dated
SF49-063

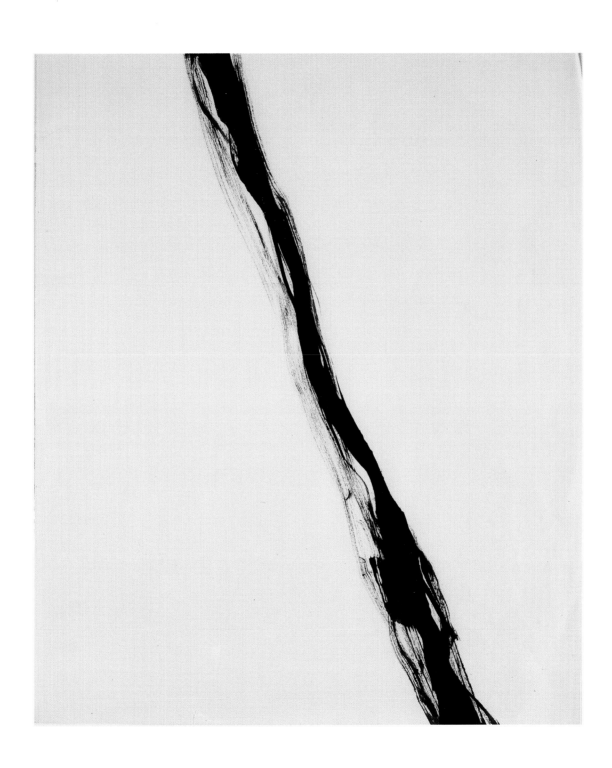

Grey Fields, Berkeley 1949
Gouache on paper
14 ³/₄ x 10 ³/₄ inches
signed twice, dated
SF49-065

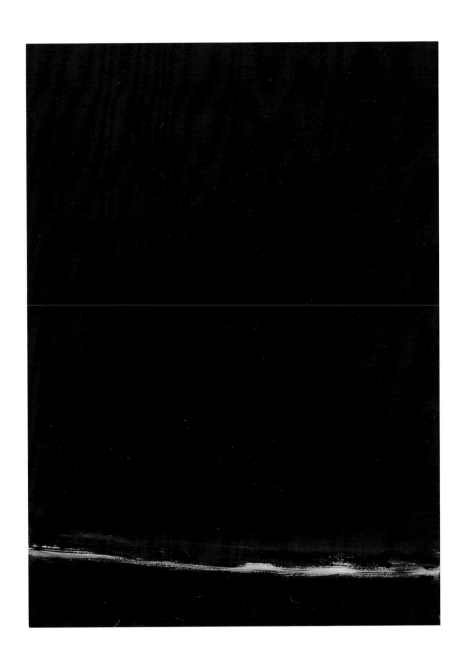

Untitled, Paris 1949-50
Ink on paper
17 ³/₄ x 15 inches
signed, dated
SF50-003

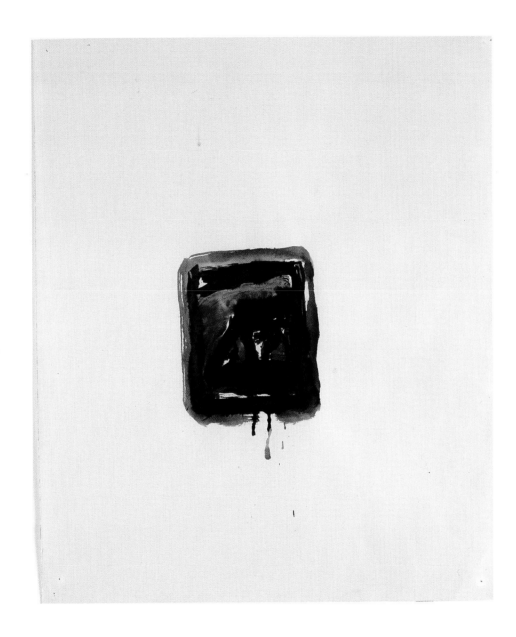

Untitled, San Francisco/Paris 1950
Ink on paper
12 ⅝ x 9 ⅝ inches
signed, dated
SF50-017

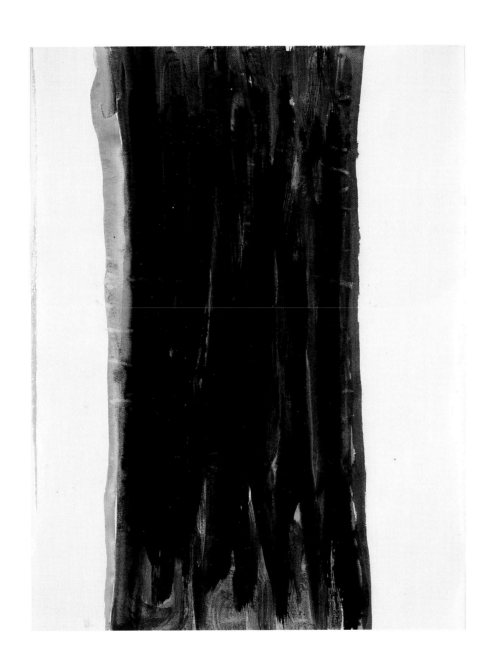

Untitled, Paris 1950
Gouache on paper
16 x 13 inches
signed, dated
SF50-037

Why do we say shades of colors?
— shadows of colors —
Who has seen pure white?

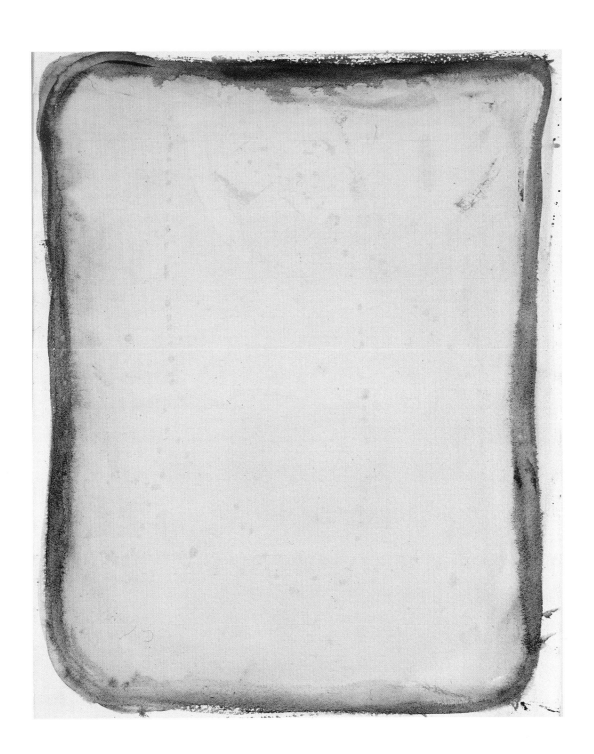

Untitled, Los Angeles 1950
Ink on paper
11 x 13 $^{15}/_{16}$ inches
signed
SF50-040

Breathing in and breathing out
the movement of my work

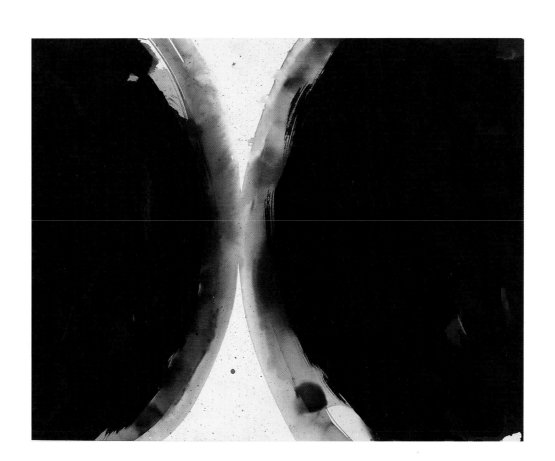

Untitled, San Francisco/Paris 1950
Ink on paper
32 $\frac{3}{8}$ x 22 $\frac{3}{4}$ inches
signed, dated
SF50-043

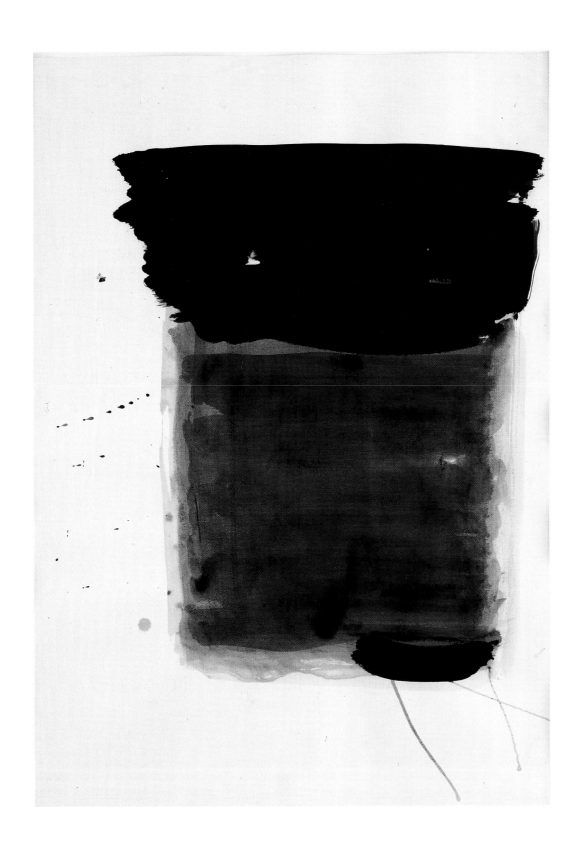

Untitled, 1950
Ink on paper
21 ⅛ x 14 ½ inches
signed, dated
SF50-81

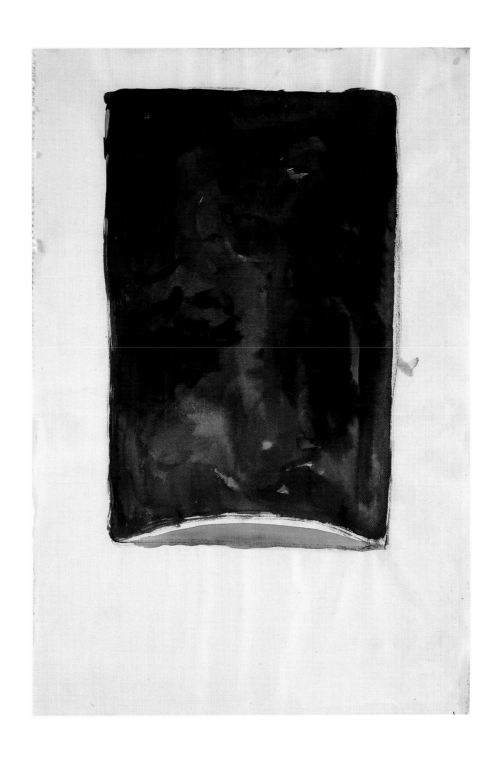

Untitled, Paris 1950-52
Ink on paper
20 ¼ x 13 ⅛ inches
signed, dated
inscribed to Madame Nina Dausset
SF50-137

Black may not be the darkest color in a picture

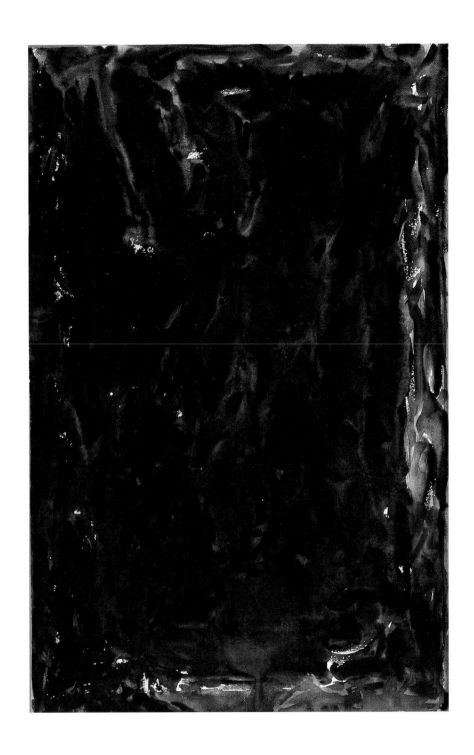

Untitled, 1950
Ink on paper
19 x 12 inches
signed, dated
SF50-140

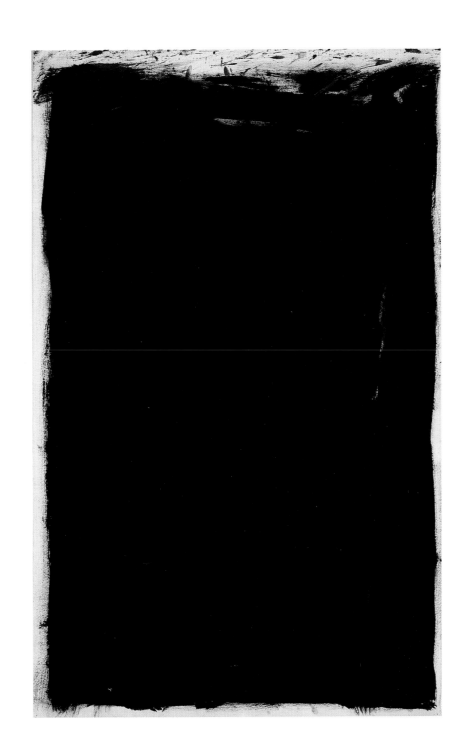

Untitled, 1950
Ink on paper
19 x 12 inches
signed, dated
SF50-141

Untitled, 1950
Ink on paper
16 $\frac{3}{4}$ x 13 $\frac{7}{8}$ inches
signed, dated
SF50-145

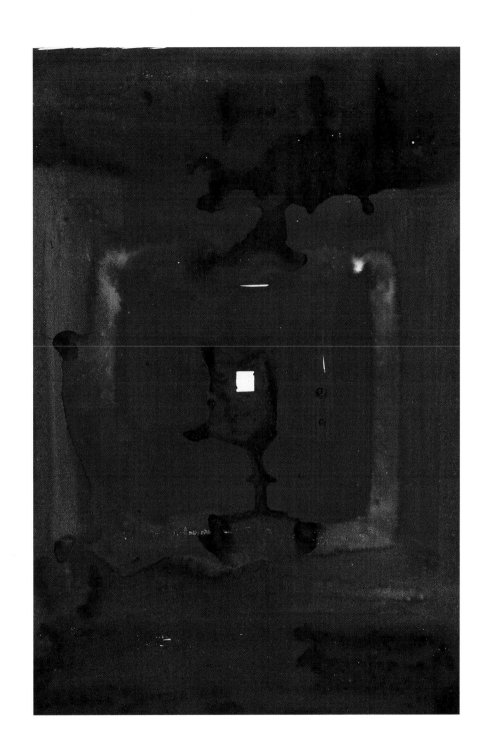

Untitled, 1950
Ink on paper
22 ³/₄ x 32 ¹/₄ inches
signed
SF50-146

This painting gets more airy as it gets darker

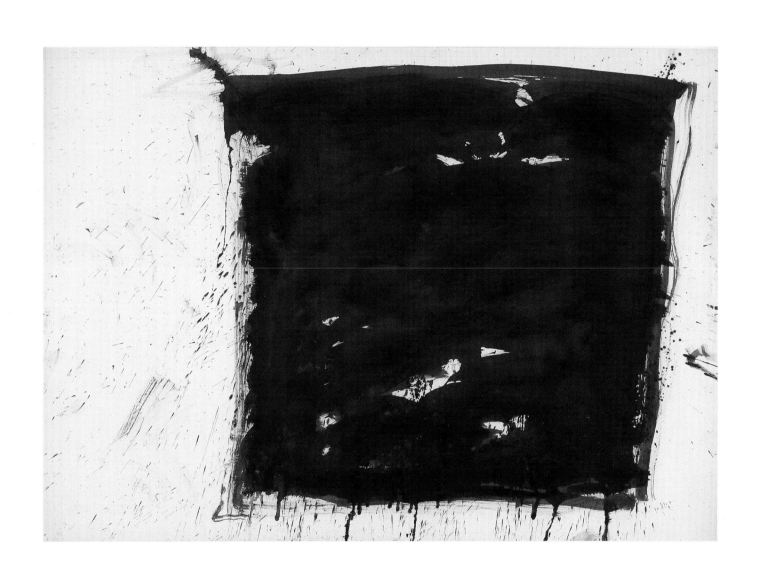

Untitled, 1951
Ink, watercolor on paper
8 ¹⁵/₁₆ x 7 inches
signed, dated
SF51-255

*Color is born
of the interpretation
of light and dark*

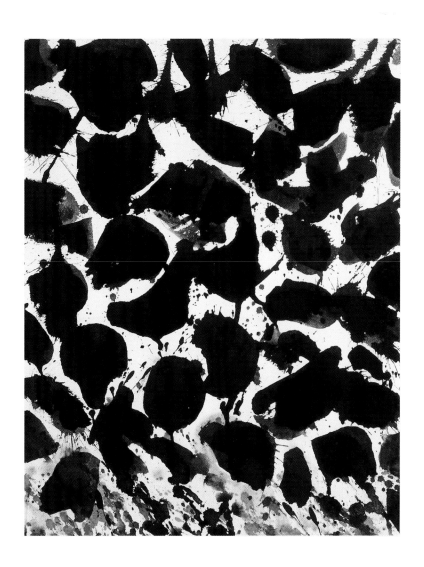

Untitled, Paris 1952
Gouache on paper
18 x 11 ¼ inches
signed, dated in blue paint
SF52-011

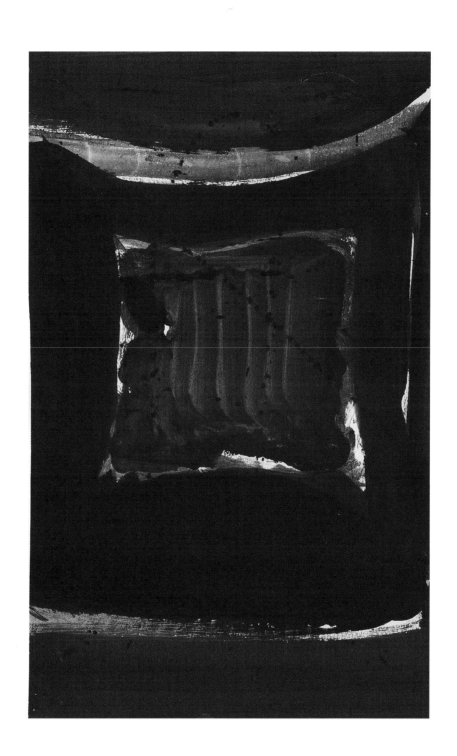

Untitled, Paris 1954
Ink on paper
22 $^{7}/_{8}$ x 19 $^{9}/_{16}$ inches
signed, dated
initials in lower left corner
SF54-025

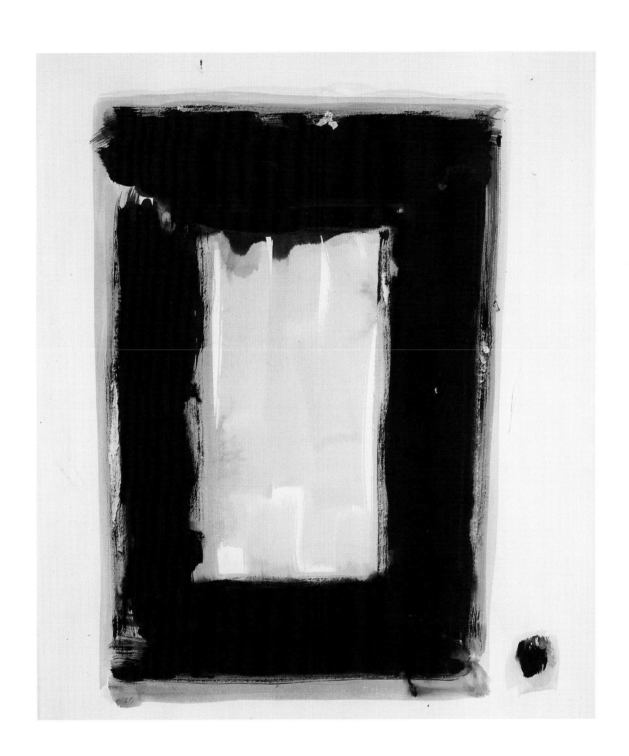

Untitled, 1954
Ink on paper
14 x 11 inches
signed, dated
SF54-071

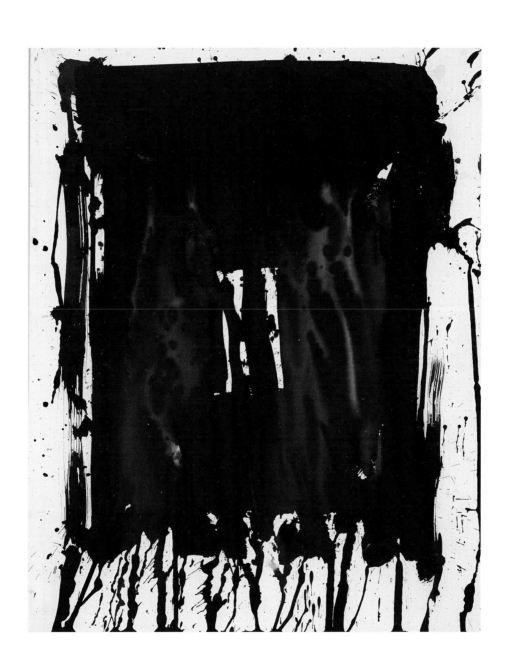

Untitled, Paris 1956
Gouache on paper
11 x 15 inches
signed, dated
SF56-006

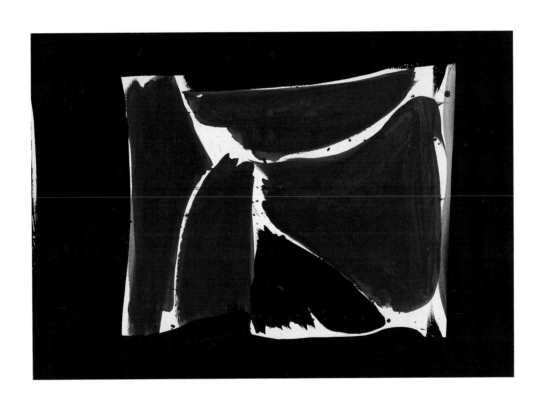

Untitled, Paris 1958
Acrylic on paper
8 x 9 $\frac{7}{8}$ inches
signed, dated
SF58-003

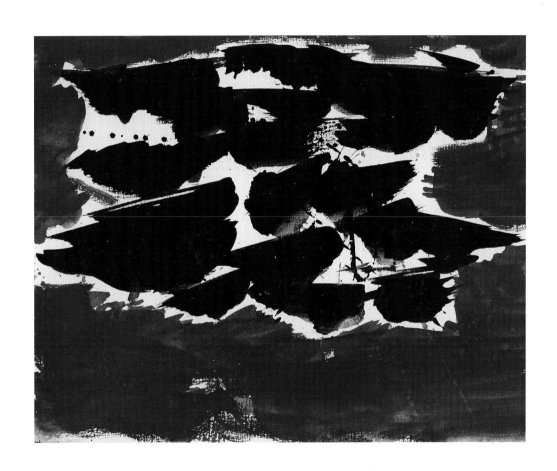

Untitled, 1958
Gouache on paper
9 7/8 x 8 inches
signed, dated
SF58-246

love is blinded by the fire of love
blinded by the light of ourselves, we need the
(other) light hiding in the shadows
in order to see.

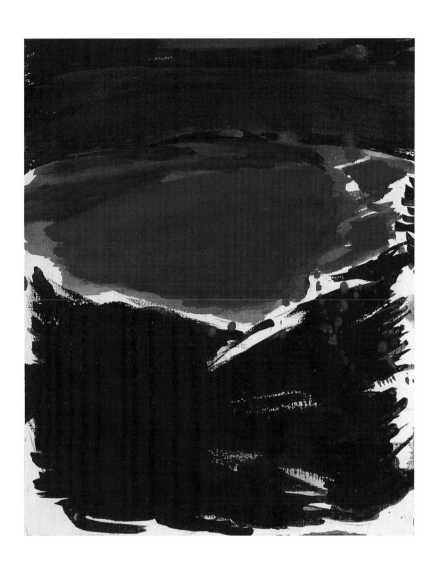

Untitled, 1959
Ink on paper
10 x 6 inches
signed, dated
SF59-348

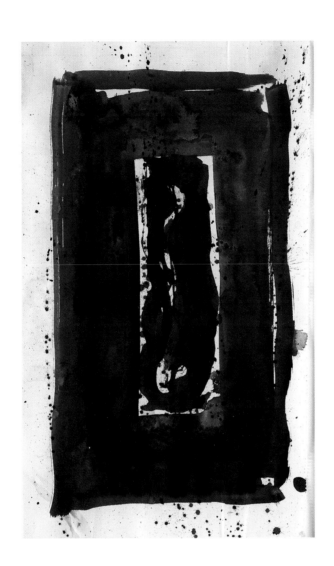

Untitled, 1959
Gouache on paper
5 ³/₄ x 7 ⁵/₈ inches
signed, dated
SF59-349

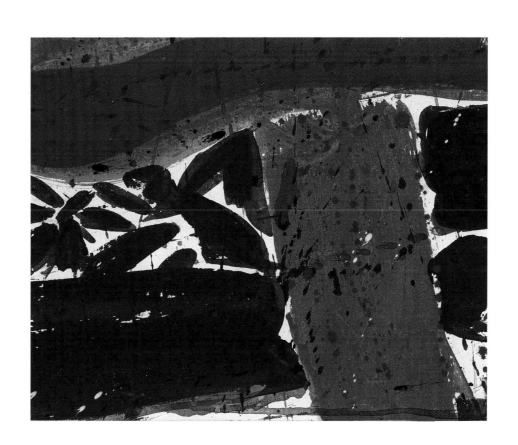

Untitled, Paris/Tokyo 1960
Watercolor on paper
18 ½ x 12 ¼ inches
signed, dated
SF60-519

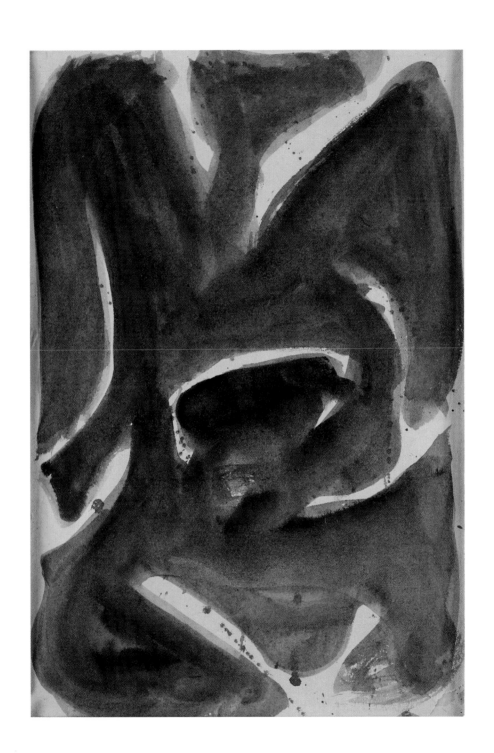

Untitled, Los Angeles 1962
Watercolor on paper
11 x 10 ¾ inches
signed
SF62-001

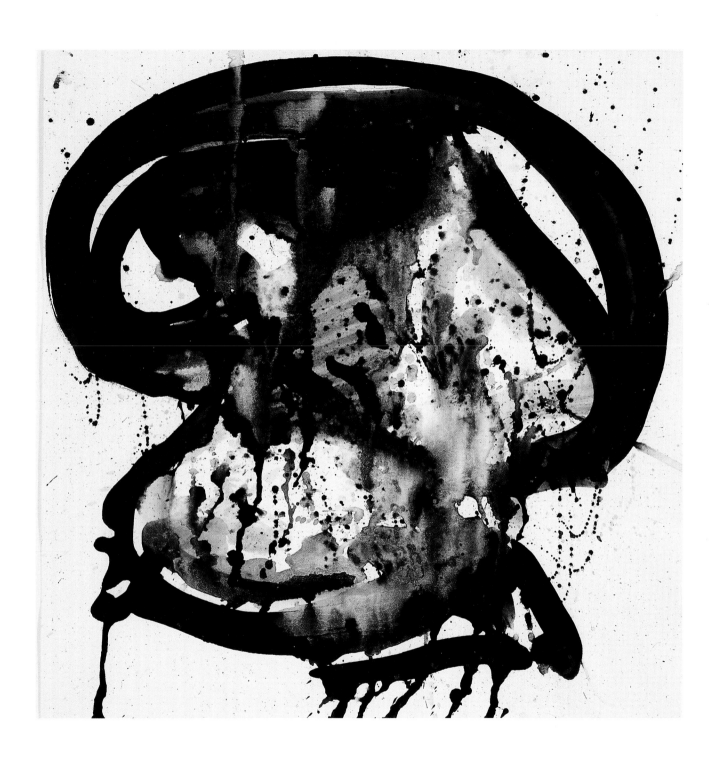

Untitled, Tokyo 1963
Ink on paper
18 ¹³/₁₆ x 15 ¹/₄ inches
signed, dated
SF63-150

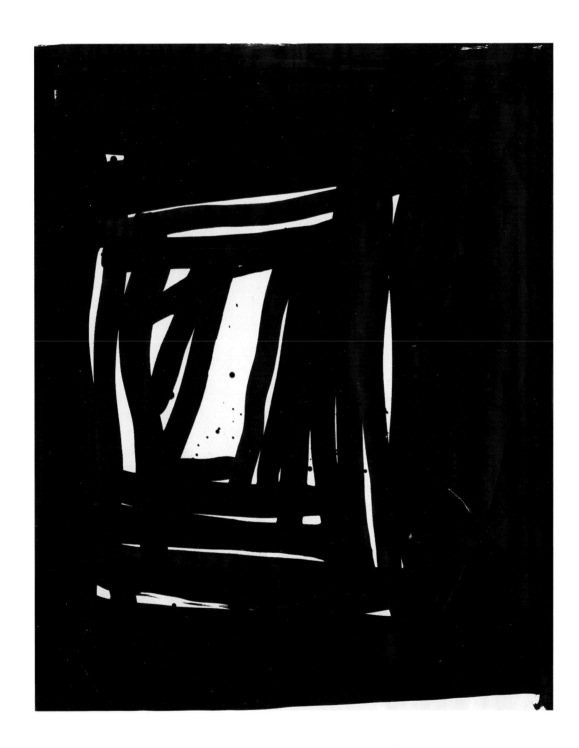

Untitled, Los Angeles 1963
Ink on paper
19 x 15 ¼ inches
signed, dated
SF63-170

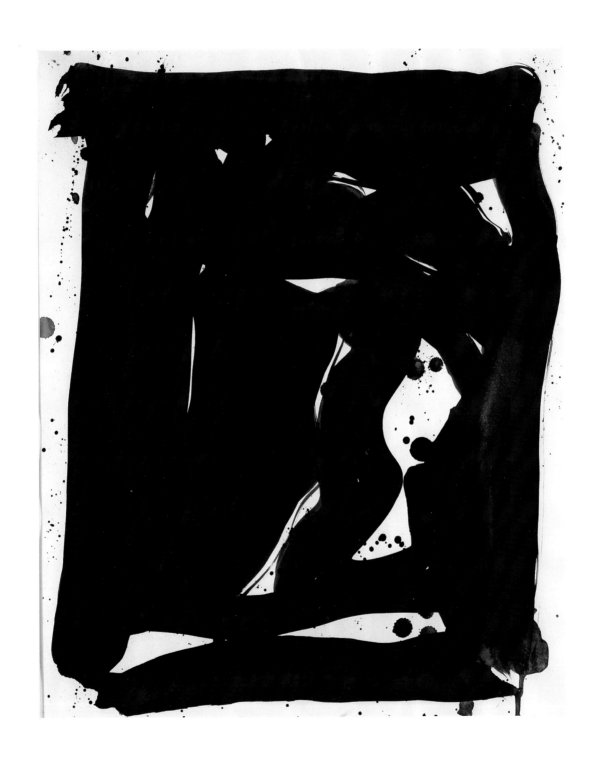

Black, Los Angeles/Tokyo 1963
Ink on paper
32 ¼ x 22 ⅞ inches
signed, dated
SF63-171

interpenetration of time and space

an increase in light
gives an increase in darkness

light and dark
are constellations of each other

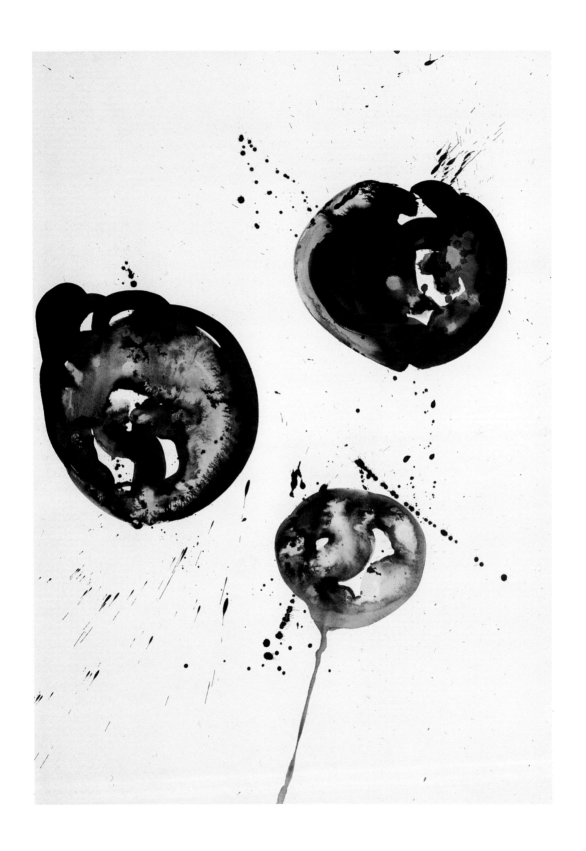

Untitled, Tokyo 1970
Ink on paper
11 x 14 inches
signed, dated
SF70-749

Time is the swiftest
of all things

darkness covers light
light fills darkness

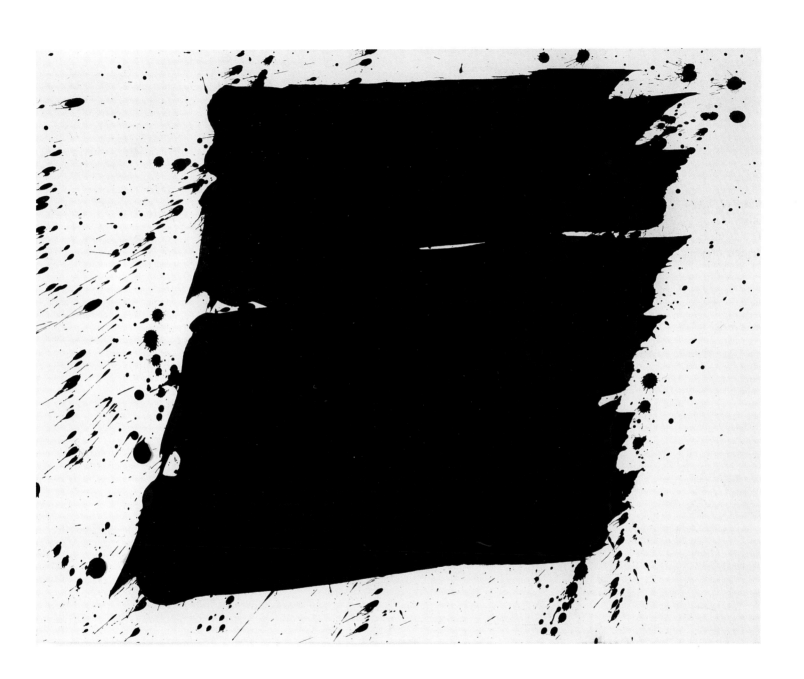

Untitled, 1972
Ink on paper
26 ¼ x 18 ¼ inches
signed, dated
SF72-1005

you and my
a mirror
What is the color of
the mirror itself?

coincidental opposites
reflect off each
other
mirror to mirror

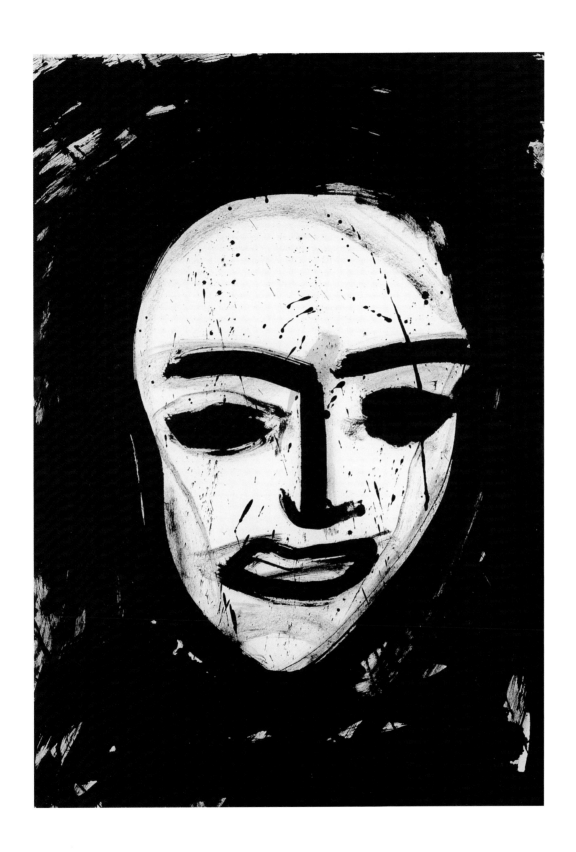

Untitled, Los Angeles 1973
Ink on paper
15 x 18 inches
signed, dated
SF73-160

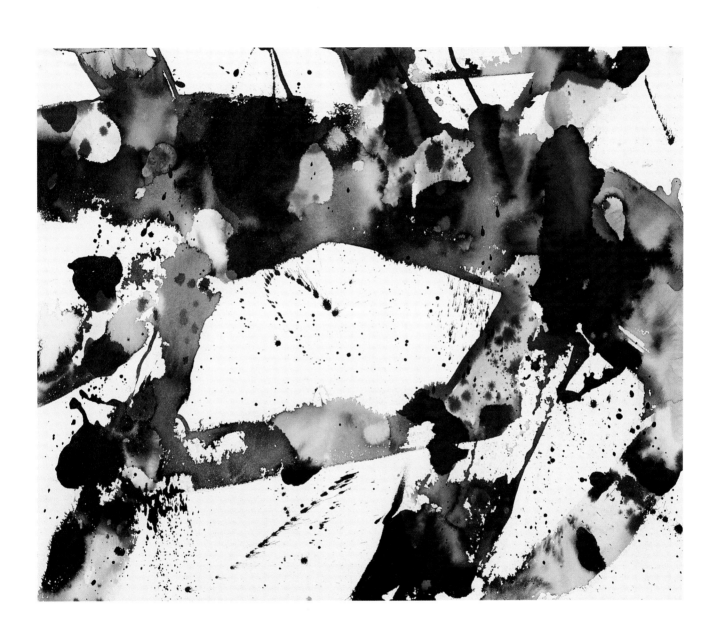

Untitled, Los Angeles 1973
Gouache on paper
19 x 15 ¼ inches
signed
SF73-162

Color cannot have ever begun and yet lasts forever

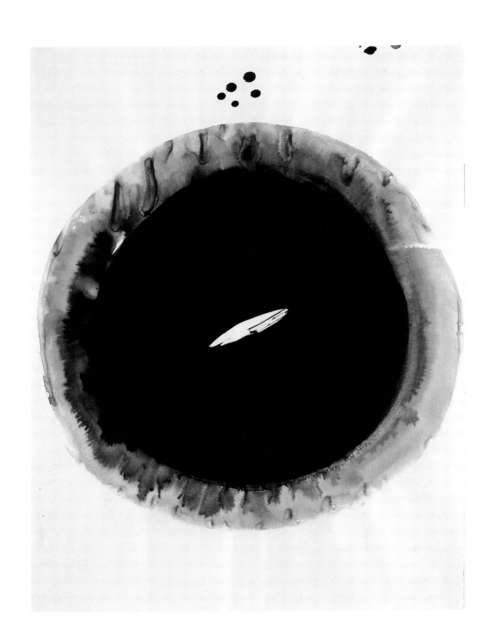

Untitled, 1974-75
Ink on paper
32 ½ x 22 ⅞ inches
unsigned
SF74-767

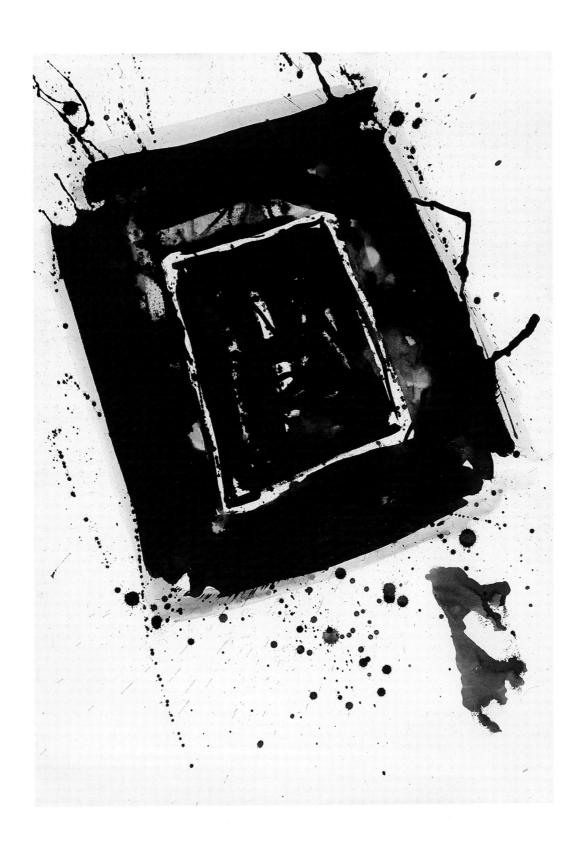

Untitled, Los Angeles 1976
Ink on paper
29 ⅝ x 22 inches
SF76-351

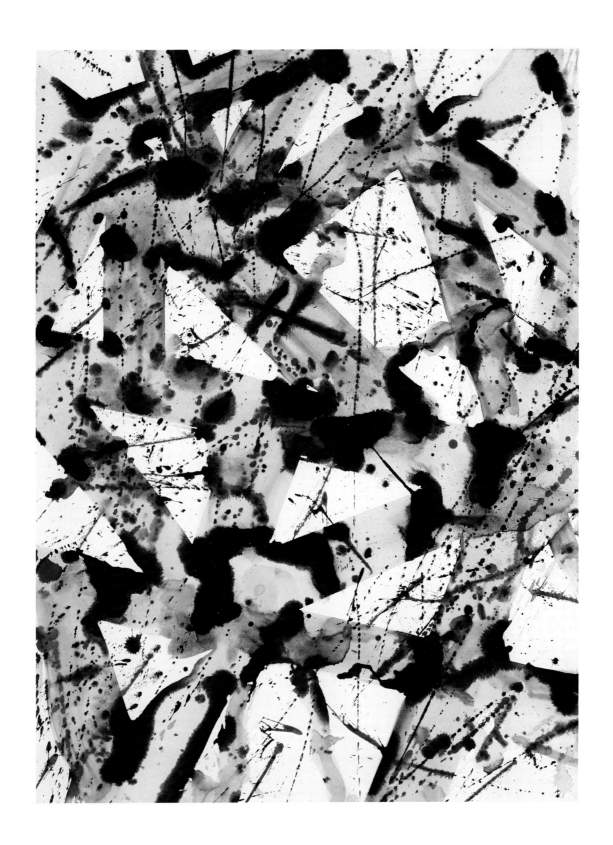

Untitled, c. 1977
Ink/acrylic on paper
29 ³/₄ x 40 inches
signed
SF77-926

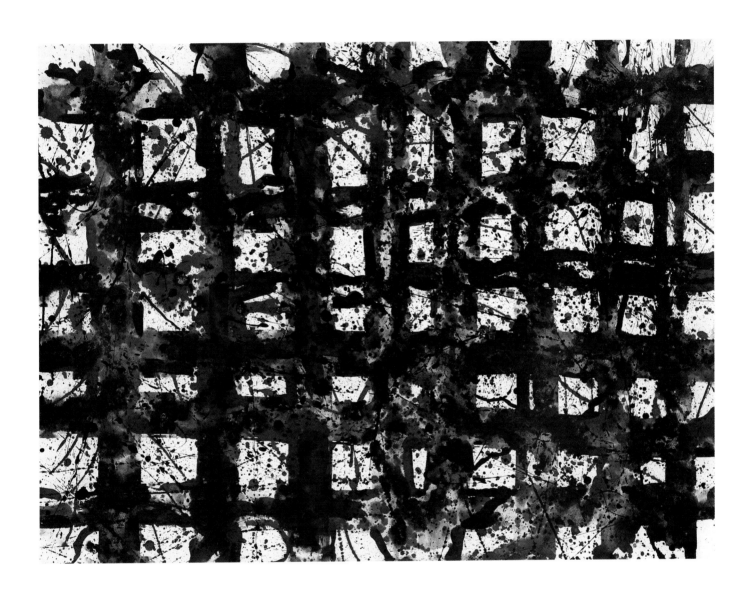

Sam Francis Chronology

COMPILED BY NANCY MOZUR

With the following acknowledgments as partial sources for this chronology: Ann Goldstein for her biography as published in the catalogue *Sam Francis,* accompanying the retrospective organized by Pontus Hulten and assisted by Uta Grosenick in 1991 at the Kunst- und Ausstellungshalle der Bundesrepublik Deutschland, Bonn, Germany; Katherine Kline for her chronology in *Sam Francis: 1947-1972,* the catalogue accompanying the traveling exhibition organized by Robert T. Buck in 1972 at the Albright-Knox Art Gallery, Buffalo, New York; *Sam Francis* by Peter Selz, (Harry N. Abrams, New York, revised edition, 1982); *Sam Francis: Sketch of His Life from the Personal View of E.W. Kornfeld,* in *Sam Francis: Eine Retrospektive, 40 Years of Friendship, Werke 1945-1990* (Galerie Kornfeld, Berne, 1991); *Sam Francis: Ideas and Paintings* by Betty Freeman (unpublished manuscript, 1969) and the very generous and kind help extended to me from the staff at the Litho Shop, Inc., and the Los Angeles County Museum of Art library.

1923-1941

Samuel Lewis Francis is born on June 23, 1923 in San Mateo, California, to Samuel Francis, a mathematics professor from Newfoundland and Katherine Lewis, a trained pianist from New York. George Francis, his brother is born three years later. At twelve, his mother dies and his father remarries to Virginia Andersen. He attends schools in San Mateo and becomes interested in science, nature, literature (particularly Herman Melville, William Blake and William Shakespeare), music and Eastern philosophy. William Elliot, a grammar school friend, becomes one of Francis' early patrons.

1941-1943

Attends the University of California, Berkeley, where he studies botany, medicine and psychology. Encounters the work of C.G. Jung.

1943-1945

Serves in the United States Army Corps. In 1944, he suffers an injury as the result of emergency landing during fighter pilot training in Tucson, Arizona. This leads to spinal tuberculosis and hospitalization in Denver, Colorado, where he lies prone in a plaster cast. Francis begins painting portraits and landscapes. A year later, he moves to Fort Miley Veterans' Administration Hospital in San Francisco where he continues to draw and paint. Encounters and studies with David Parks, an expressionistic figure painter and teacher at California School of Fine Arts during hospital stay. Through Parks, Francis becomes acquainted with the art of Paul Klee, Pablo Picasso and particularly Joan Miró. Goes to the California Palace of the Legion of Honor in a wheelchair, his first museum visit.

1946

One watercolor is included in *66th Annual Exhibition* of the San Francisco Art Association, San Francisco Museum of Art. Paints his first abstract paintings.

1947

Develops contacts at the California School of Fine Arts, lead by Douglas MacAgy, who brought to the school such visiting artists as Clyfford Still, Mark Rothko, Ad Reinhardt and Edward Corbett. Other artists such as Elmer Bischoff, Frank Lobdell, Hassel Smith and Richard Diebenkorn were on the faculty. Best friends with artist Fred Martin who later becomes director of the San Francisco Art Institute. Released from Fort Miley Veteran's Administration Hospital and the army. Marries Vera Miller (divorced 1950). Paints heavily-textured biomorphic and geometric shapes during this period.

1948-1950

Tuberculosis is considered arrested. Returns to the University of California at Berkeley to major both in art and art history. Receives B.A. in 1949 and M.A. in 1950, studying with James McCray and Edward Corbett. He encounters the work of Still, Rothko, Pollock, Tobey, Gorky and Baziote during this time, all of which prove influential in his development as a young artist. Fire at father's house destroys half his paintings.

1950

Moves to Paris on the "G.I. Bill" with the painter Muriel Goodwin, whom he marries (divorced approximately 1959). First year lives and paints in Hôtel de Seine. Studies briefly at the Académie Fernand Léger. Establishes through his contact with Canadian painter Jean-Paul Riopelle, friendships with other American artists living in Paris at this time; Shirley Jaffe, Al Held, Kimber Smith, Norman Bluhm, Joan Mitchell, Ruth Francken, John Hultberg and the writer Rachel Jacobs. Also meets Alberto Giacometti and Bram van Velde as well as critics Pierre Schneider, Charles

Estienne and Georges Duthuit, son-in-law of Henri Matisse. Exhibits one work in the *VIe Salon de Mai* at the Musée d'art moderne de la Ville de Paris.

1951

Lives in Sèvres, France, during the year with Muriel. Later settles in Paris again, living and working in small studio on Boulevard Arago. Meets Pontus Hulten during this time. Becomes absorbed in work of Henri Matisse. Exhibits first monochromatic grey or white paintings in a group exhibition at the Galerie du Dragon, Paris. Spends summer with the Duthuits near Aix-en-Provence. Painting at this time is broadly monochromatic with subtle all-over cellular forms and the beginning of edges containing the center. This is exemplified in such works as *Grey, Pale Green* and *Composition in White*.

1952

Francis becomes acquainted with Michel Tapié and Patrick Waldberg, both active Paris-based critics. First solo exhibition organized by Nina Dausset of large white paintings at Galerie du Dragon. Included in Paris exhibition *Signifiants de l'informel,* organized by Tapié at Studio Paul Facchetti, Paris. Spends summer with the Duthuits and briefly visits the *Venice Biennale* where he discovers Byzantine art. Madame Henri Matisse purchases an early Paris painting. In addition to white paintings, Francis creates monchromatic paintings with veils of darker color composed of cellular forms. Light comes through veils of darkness (at times color is pushed to the point of blackness; black is used not as a color but as a means of intensifyinglight) as shown in such works as *Blue Black*.

1953

Moves studio to 15e arrondissement of Paris, Rue Tiphaine 14 in Montparnasse. He is greatly impressed by Claude Monet's *Nymphéas,* newly installed at the Orangerie. Included in the exhibition *Un art autre* at Studio Paul Facchetti, organized by Tapié, who identifies a new informel art, often called "Tachisme". Included in the *Opposing Forces* exhibition at the Institute of Contemporary Art in London.

1954

Summer trip to California, returning to Paris via New York. Included in the American painting exhibition at the Art Institute of Chicago and other group shows at Galleria di Spazio, Rome; Galerie Rive Droite, Paris; and Galerie Arnaud, Paris. Introduced to Arnold Rüdlinger, Director of the Kunsthalle, Berne, and begins long and professional friendship with Eberhard W. Kornfeld who represents Francis to the present day. Later, Kornfeld gives Francis a studio in Berne on his property. In the painting during this time, white as space and color begins to interject into the veils of paint, breaking up the cellular forms as exemplified in such works as *Big Orange* and continuing in 1955 in *Red in Red* and *Deep Blue and Black*.

1955

First major museum exhibition, *Tendances actuelles de l'École de Paris III*, at the Kunsthalle, Berne. Included in the *1955 Pittsburgh International Exhibition of Contemporary Painting and Sculpture,* Museum of Fine Arts, Carnegie Institute, Pittsburgh; and *Art in the 20th Century,* San Francisco Museum of Art. Second solo exhibition at Galerie Rive Droite, Paris. Rüdlinger purchases *Deep Orange and Black* (1954-55) for the Swiss collectors association, La Peau de l'Ours, which eventually becomes part of the permanent collection in the Kunstmuseum Basel. On initiative of Dorothy Miller and Alfred H. Barr, Jr, Museum of Modern Art in New York acquires *Black in Red* (1953), Francis' first painting to enter a public collection in the United States. Meets in New York and begins long friendship with poets and writers Makoto Ooka and Yoshiaki Tono. Begins series of abstract and erotic line drawings in ink.

1956

Meets Dr. Franz Meyer, Sr, who becomes a close friend, patron and collector of work. Spends summer in Southern France at Paradou, Bouche du Rhône and moves to a larger studio on 4 Rue Domrémy in Arcueil. Begins work on triptych mural panels for the Kunsthalle, Basel. Meets both writer and poet, Shuzo Takiguchi and Jean Fournier, his longest ongoing business relationship and personal friendship in Paris. Albright-Knox Art Gallery, Buffalo, purchases *Blue Black* (1952). First museum exhibition in the United States, *Twelve Americans,* organized by Dorothy Miller. Also included in *Expressionism 1900-1955,* Walker Art Center, Minneapolis (travels through United States); *New Trends in Painting,* organized by Arts Council Gallery, Cambridge (travels in Great Britian through 1957); and *Junge Amerikanische Kunst* at the Kunstverein Iserlohn, Westfalen (travels to Kunstmuseum, Düsseldorf). Solo exhibitions at Martha Jackson Gallery, his first in New York; as well as at Galerie Rive Droite, Paris and Zoe Dusanne, Seattle. In Francis' work, the white of the canvas increasingly starts breaking up

and coming through the color leaving more translucent veils of congregated shapes as in *In Lovely Blueness* and *Basel Mural I-III*.

1957

Retaining Arcueil studio, Francis relinquishes permanent residency in Paris. Travels from January to November around the world, including stopovers and extended stays in New York, Mexico, California, Japan and returning to Paris via Hong Kong, Thailand, India and Italy. While living in a temple in Tokyo, Francis paints large mural, *Tokyo Mural,* for the Sogetsu-Kaikan, a school created by the sculptor and flower arranger Sofu Teshigihara. Meets Kusuo Shimizu who becomes an important friend and dealer of Minami Gallery, Tokyo. Francis is awarded prize at Fourth International Art Exhibition in Tokyo. Meets Sazo Idemitsu who becomes patron and close friend, later building a studio for Francis (could possibly have met later in 1960). First one-person exhibition in Japan at Hyakkaten Tokyo Department Store, Tokyo, and Kintetsu Department Store, Osaka. Solo exhibitions at Gimpels Fils, Ltd., London; Galerie Kornfeld und Klipstein, Berne; and Martha Jackson Gallery, New York. Paintings take on a pronounced influence from Oriental art, a style reaching its first full statement with *The Whiteness of the Whale* and *Towards Disappearance III.* Paintings inspired by Herman Melville's *Moby Dick.*

1958

In February, completes large triptych mural for the stairwell of the Kunsthalle, Basel; included there in the Museum of Modern Art's international exhibition *The New American Painting* which traveled to Milan, Madrid, Berlin, Amsterdam, Brussels and London. Basel Mural remains on view until end of exhibition but the commissioned work is not approved for museum purchase. The panels are later separated (middle panel is purchased by Stedelijk Museum, Amsterdam, the remaining two panels are exhibited in *Documenta III,* 1964; later, the right-hand panel is water-damaged and returned to U.S. while the left-hand panel is donated to the Pasadena Art Museum in 1967). Spends spring in New York, living at Chelsea Hotel and returns to Paris in summer. In September, he leaves for second round-the-world journey visiting Rome, Saigon, Tokyo and California. Arrives back in New York where he primarily resides until January 1960 at the Chelsea Hotel. Paints in Larry River's studio which is shared part time by Al Held. Museum of Modern Art, New York, acquires *Big Red* (1953). Major exhibitions at Centre Culturel Américain, Paris (with

Kimber Smith and Shirley Jaffe); Brussels World's Fair and the Phillips Collection, Washington, D.C., as well as solo shows at Martha Jackson Gallery, New York; Zoe Dusanne Gallery, Seattle; and Galerie Alfred Schmela, Düsseldorf. The trails of paint that were once gestural and calligraphic in Francis' work start developing into sharp jagged forms as in *Over Yellow II, Round the World* and *Meaningless Gesture,* often depicting "land masses" and "islands" of color.

1959

After recuperating for six weeks in San Mateo from a hernia operation (which resulted from the *Basel Murals* falling on him in the studio), Francis returns to New York in February, where he spends six months working on a mural for the Director's lounge and dining-room of the Chase Manhattan Bank branch at Park Avenue and Fifty-fifth Street. That year he exhibits work in *Documenta II,* Museum Fridericianum, Kassel, and *V Bienal,* Museu de Arte Moderna, São Paulo. Marries Teruko Yokoi (divorced 1963). Birth of daughter, Kayo Andrea Francis, his first child. Draws first lithographic stones at Tatyana Grossman's workshop, Universal Limited Art Editions, Long Island, New York. (Completes this series in 1968.) Major traveling exhibition at Pasadena Art Museum, Seattle Art Museum and San Francisco Art Museum. Solo exhibitions at Galerie Kornfeld und Klipstein, Berne; Kunstverein für die Rheinlande und Westfalen, Düsseldorf; Zoe Dusanne Gallery, Seattle; and Galerie Olaf Hudtwalcker, Frankfurt am Main. In the paintings, the forms on the canvas become polarized opposites cleaved apart by the whiteness of the center. This is exemplified in such works as *Emblem* and *White Line.* Francis also begins to explore small scale in collage works on paper.

1960

Returns to Paris in January, traveling back and forth between Paris, Berne and Tokyo. Retains studios in all of those cities as well as New York. Meets and begins close friendship with painter and poet Walasse Ting. During summer makes first series of sixteen lithographs at the Zurich studio of Emil Matthieu, and publishes them through Eberhard Kornfeld. In summer visits *Venice Biennale* where he meets Austrian artist Kiki Kogelnik. Major exhibitions at Kunsthalle, Berne (travels to Moderna Museet, Stockholm), as well as gallery shows at David Anderson Gallery, New York; Galerie de Seine, Paris; and Galleria La Notizie, Turin. Begins *Blue Ball* series (through 1963) in which blue becomes primary color in his work

floating against the white of the canvas. These spherical shapes also line up along the edges delineating a wash-like center, as in *Blue in Motion III*, or appear to be elongated daimon-like forms, *Blue Figure*.

1961

Becomes ill in Tokyo. From February until November hospitalized in Berne for tuberculosis of the kidney. Works extensively in watercolor during hospitalization. Released from Tiefenau hospital in mid-November and returns to convalesce in Santa Barbara. Included in *Arte e contemplazione*, Palazzo Grassi, Venice, as well as exhibiting in gallery shows at Galerie Kornfeld und Klipstein, Berne: Galerie Jacques Dubourg, Paris; Gres Gallery, Chicago; Minami Gallery, Tokyo; Galerie Alfred Schmela, Düsseldorf; David Anderson Gallery, New York; Galerie Nächst St. Stephan, Vienna; and Grabowski Gallery, London. First print shows at Galerie Il Segno, Rome; Graphisches Kabinett Weber, Düsseldorf; Dayton Art Institute, Dayton; and Galerie Kornfeld und Klipstein, Berne. Continues *Blue Ball* and ink drawings of configurations on paper, primarily due to his illness in which he was forbidden to paint in oil.

1962

Settles in Santa Monica, California, where he buys a home on West Channel Road. Continues to maintain studios in nearby Venice Beach as well as Paris, Tokyo and Berne. Wins Grand Prize at the *Third International Biennial Exhibition of Prints*, Tokyo, for the lithograph *White Line* (1960). In Los Angeles, meets Walter Hopps, who becomes a close friend. Exhibition of lithographs at Bezalel National Museum, Jerusalem. Solo exhibitions at Esther Bear Gallery, Santa Barbara; Galerie Edwin Engelberts, Geneva; Galerie D. Benador, Geneva; Galerie Olaf Hudtwalcker, Frankfurt am Main; Galerie Alice Pauli, Lausanne; Galerie Lacade, Paris and Galerie Dieter Brusberg, Hanover. Primary colors are introduced into the spherical forms of the paintings as exemplified in the work *Why Then Opened I* and *II*.

1963

Works in Santa Monica and Berne during the year. From March to August in residence at Tamarind Lithography Workshop in Los Angeles which increases his commitment to printmaking. Works on another series of lithographs in Zurich and at Joseph Press, Venice, California. Death of long-time friend and patron Franz Meyer, Sr. Largest exhibition to date is at Kestner-Gesellschaft,

Hanover. The Tate Gallery, London, acquires a major canvas, *Round the Blues* (1957) as a purchase award at the *Dunn International*, Beaverbrook Art Gallery, Fredericton, New Brunswick. Included in *Visione-Colore*, Palazzo Grassi, Venice. Solo exhibitions at Martha Jackson Gallery, New York; Galerie Anderson-Mayer, Paris; and I Gallery, La Jolla.

1964

Most of the year is spent in Japan. Meets filmmaker and video artist Mako Idemitsu. Develops close friendship with poet Bernard Forrest in Los Angeles. Edits and contributes six lithographs to *1 Cent Life*, a portfolio published by Eberhard W. Kornfeld with poems by Walasse Ting and sixty eight original lithographs by twenty-eight international artists. In Kyoto and later Tokyo, Francis creates his first sculpture, four blue and white ceramic wall pieces. Designs an art gallery for patron-collector Sazo Idemitsu in Tokyo (later it is turned into business offices). First monograph on Francis' work is authored by Yoshiaki Tono, *Sam Francis: The Flesh of Mist* and published by Misuzu Shobo in Tokyo. Collaborates (creates eight gouaches) with poet Shuzo Takiguchi to produce livret *You the Yellow* for exhibition at Minami Gallery in Tokyo. Makes one lithograph at Koyama Press in Tokyo and later works at Matthieu's workshop in Zurich. Develops a close friendship with Edwin Janss, Jr. Studio assistants in Santa Monica at this time are Irving ("Doc") and Spike Groupp as well as Lucius Hudson. Major exhibitions include *Documenta III*, Museum Fridericianum, Kassel, where he exhibits two of the large paintings from the Kunsthalle, Basel, stairwell commission as well as other work; Pasadena Art Museum, Pasadena, and solo gallery shows at American Art Gallery, Copenhagen; Martha Jackson Gallery, New York; Galerie Ernst Hauswedell, Baden-Baden; and Lanyon Gallery, Palo Alto. Begins *Bright Ring Drawings* with emphasis upon the compositional edge. Spherical forms and gestural explosions still appear in the work from this year but gradually are pushed to the edges and disappear.

1965

Marries Mako Idemitsu (divorced in early 1980's). Gives up New York studio and builds larger studios at Santa Monica house. In Japan, he works on a large free-standing ceramic sculpture. Begins to paint *Drawing for Sculpture* series on paper. Collaborates with poet Makoto Ooka and creates a lithograph, *Water Buffalo*, for Japanese Art Association. Makes fifty color variant lithographs on zinc plates

in Tokyo. Offers to serve as consultant to Pasadena Museum as it was in process of selecting architect for its new building. Suggests Arata Isozaki, who is seriously considered but does not receive the commission. Major exhibitions at Württembergischer Kunstverein, Stuttgart; Scottish National Gallery of Modern Art, Edinburgh (with Richard Diebenkorn) and solo gallery shows at Galerie Kornfeld und Klipstein, Berne; Galerie Ricke, Kassel; Honolulu Academy of Arts, Honolulu; Arthur Tooth and Sons, Ltd., London; and Auslander Gallery, New York. Color and form, now pushed to the edges, serve metaphorically as windows and thresholds to the center of the white canvas. At first the edges are painted wide and opaque as in *Iris* but eventually they evolve over the next four years into narrow, translucent bands around the edges leaving more white space exposed, as seen in *White Ring*. The central white of the canvas changes in tonal quality with each painting.

1966

Establishes a residence in Tokyo. Birth of his first son, Osamu William Francis, named after friend William Elliot who died tragically that year. Completion of *Pasadena Box* (commissioned in 1962 and published by the Art Alliance of the Pasadena Art Museum), a multiple comprising of twelve lithographs, one scroll, a triptych and one original gouache contained in three drawers of a plastic cube. Artist in residence at Tamarind Lithography Workshop in September. From September 1966 through December 1967, involved (with Walter Hopps, the Director of the Gallery of Modern Art in Washington, D.C., art critic Jules Langsner and artists Ed Moses, Billy Al Bengston, Kenneth Price, Larry Bell, Edward Ruscha and several Los Angeles area patrons of the arts) in planning the *New Art Project* for an arts foundation in Los Angeles which would provide a focal point for artists to communicate with each other and serve as an institute for analytical thought and a center for architectural, musical and political activities. The project, never realized, was based on the premise that "the ideas of the artist should be used to reconstruct society". Hired as consultant on planning of ski village of Snowmass near Aspen, Colorado. His report on preliminary project is an eloquent statement about natural beauty and man's responsibility to it. Collaborates with Japanese composer Toshi Ichiyanagi on an opera. While in Japan he is asked by the Tokyo newspaper Yomi Youri Shimbun to do sky painting. Makes drawings for each of five helicopters (one of which is directed by Francis), which trail separate colored pigment streams of blue, red, magenta, yellow and white 8000 meters over Tokyo Bay.

Maria Reinshagen begins numbering and documenting works on paper. Kunstmuseum, Basel, purchases *Meaningless Gesture* (1958) while the Kunsthalle, Hamburg, purchases *As for the Open* (1962-63). His work is included in *Two Decades of American Painting*, circulated by the Museum of Modern Art through Japan, India and Australia. Other major exhibitions at Galerie Kornfeld und Klipstein, Berne; Galerie Edwin Engelberts, Geneva; Pasadena Art Museum, Pasadena; California State College, Fullerton; and Minami Gallery, Tokyo.

1967

Produces a ski painting performance at the resort of Naibara, Japan. Works at the Irwin Hollander Workshop, producing lithographs and was included in the project *Portfolio 9*. Bought used press from Tamarind Workshop and put it in Santa Monica studio for future printmaking projects. Studio assistant at this time was John Bennett who eventually remains in Arcueil studio in France. Entry for outdoor sculpture show in Century City, Los Angeles, consisted of thousands of colored balloons to be discharged at night accompanied to disappearance by colored searchlights (never executed). Major retrospective exhibition at the Museum of Fine Arts, Houston, organized by James-Johnson Sweeney (travels in 1968 to the University Art Museum, University of California, Berkeley). Major survey of drawings and lithographs at San Francisco Museum of Art (traveling to Dickson Art Center, University of California, Los Angeles). Solo exhibitions at Pierre Matisse Gallery, New York; Dom Galerie, Cologne; and Galerie Hollar, Prague.

1968

From January to June in Tokyo, returning to Los Angeles via Switzerland. Death of old friend Arnold Rüdlinger, director of Kunsthalle, Basel; Francis writes an obituary published in the catalogue accompanying his exhibition at the Kunsthalle, Basel (travels to Badischer Kunstverein, Karlsruhe, and the Stedelijk Museum, Amsterdam). Begins once again to work primarily in oils for first time since 1960. Collaborates with group called *Single Wing Turquoise*, producing light shows using projected slides, disks, strobe light and liquids to create a patterned play of changing colored lights against mulitple screens. Involved in the peace movement and protests against the Vietnam War. Francis organizes and sponsors a helicopter which flew over the demonstrations at People's Park in Berkeley, trailing the banner *Let a Thousand Parks Bloom*. Writes an essay on Pierre Bonnard, *Bonnard, or Be Kind to Yourself Human Being*, for the Japanese

periodical Bijutsu Techo which provides a revealing commentary on his own painting. Major exhibition at the C.N.A.C. (Centre National d'Art Contemporain), Paris, of primarily edgeworks. Solo exhibitions at Tokyo Central Bijutsukan Gallery, Tokyo (travels to Gutai Pinacotheca, Osaka); Minami Gallery, Tokyo; Galerie Gunther Franke, Munich; and Galerie Du Bac, Paris. *Pasadena Box Suite* exhibited at Martha Jackson Gallery, New York and Galerie Kornfeld und Klipstein, Berne.

1969
Spends entire year in Santa Monica after traveling briefly to Berlin, Paris and New York. Birth of second son, Shingo Jules Francis. Receives an honorary PhD from the University of California at Berkeley and is chosen as an outstanding alumni to serve on the board of directors of its art gallery. Receives commission for a mural from the Neue National-galerie (designed by Ludwig Mies van der Rohe) in West Berlin. Rents a studio on Ashland and Main Street in Ocean Park area to paint the *Berlin Mural* (completed in 1970 and not fully seen until installed at the museum); shares studio with Richard Diebenkorn and later Charles Garabedian. Betty Freeman, an early patron of Francis, completes *Sam Francis: Ideas and Paintings,* a 212 page unpublished manuscript including text by Freeman, poems about Francis by Yoshiaki Tono, Sinclair Beiles, Shuzo Takiguchi and a reproduction of Francis' handwritten essay on Bonnard. The manuscript describes Francis' personality, influences and life as well as an exhibition record up to 1969. Francis is invited to participate in the *Art and Technology* program of the Los Angeles County Museum of Art, an exhibition presented in 1971. Works over a nine month period on ideas for a light show performance and a project executing sculpture in cement or ceramics (these are never realized). Begins professional relationships with André Emmerich in New York and Nicholas Wilder in Los Angeles. Major exhibition at Santa Barbara Museum of Art, Santa Barbara. Solo exhibitions at Shasta College, Redding; University of Minnesota, Minneapolis; André Emmerich Gallery, New York; Nicholas Wilder Gallery, Los Angeles; and Felix Landau Gallery, Los Angeles.

1970
Spends spring in Berne and Paris. Returns to Santa Monica for the summer, returning in the fall to Berne and Paris. Establishes the Litho Shop at 1664 20th Street in Santa Monica (later incorporated in 1973 under the direction of Nancy Mozur until 1989). There he collaborates on lithographic editions with Master Printer Hitoshi Takatsuki, assisted by Keith Kirts and Lloyd Baggs. Studio assistants at this time are Krauth Brand, Jerry Aistrup and Dan Cytron. The Litho Shop also serves as a center to manage Francis' operations, exhibitions and archives. Begins friendship and professional association with Paula Kirkeby through Galerie Smith Andersen, Palo Alto. Major exhibition of edgeworks at the Los Angeles County Museum of Art as well as solo shows at Martha Jackson Gallery, New York; Galerie Smith Andersen, Palo Alto; and Minami Gallery, Tokyo. Paintings are primarily oil and acrylic on canvas in which the edge-works start either dissolving into colorful rock-like forms in the corners of the canvas as in *Berlin Mural* and *Berkeley,* or the edges shoot forth very delicate matrixes, dissecting the center of the painting, as in *Looking Through.*

1971
Resides and works in Santa Monica and Tokyo. Makes first series of lithographs at Gemini G.E.L., Los Angeles, which marks the beginning of continued limited editions of lithographs, screenprints and etchings at this workshop through 1986. In the fall, starts work with Dr. James Kirsch, a Jungian analyst, marking the beginning of his ongoing involvement in Jungian psychology. Included in the *32nd Corcoran Biennial,* Washington, D.C. Solo exhibitions at André Emmerich Gallery, New York; Martha Jackson Gallery, New York; and Gemini G.E.L., Los Angeles.

1972
Resides in Santa Monica. First major retrospective exhibition in the United States organized by Robert T. Buck, Jr, director of the Albright-Knox Art Gallery, Buffalo (travels to Corcoran Art Gallery, Washington, D.C.; Whitney Museum of American Art, New York; Dallas Museum of Fine Arts, Dallas; and the Oakland Museum of Art, Oakland, through 1973). *Sam Francis: These are My Footsteps,* a film directed by Dan Healy with commentary concerning the retrospective exhibition by Robert T. Buck, Jr, and Sam Francis is produced for WNED television. Makes first series of aquatints with Walter and Eleanora Rossi at Studio 2RC, Rome (completed in 1973). Death of his father, Samuel A. Francis on December 28. Major exhibitions at Stanford University Museum, Stanford; Loretto-Hilton Center, Webster College, St. Louis; Fresh Air School, Museum of Art, Carnegie Institute, Pittsburgh (traveling show through 1974 with Walasse Ting and Joan Mitchell), and solo gallery shows at André Emmerich Gallery, New York; Galerie Smith Andersen, Palo Alto; and Gemini G.E.L., Los

Angeles. Paintings continue to show matrixes made up of opaque structure dissolving into watery channels. There is a sense of more enclosed formations as well as "torrey" or gatelike structures, moving or anchored in front of the whiteness of space. Examples can be seen in such paintings as *Untitled No.16* and *Entrance*.

1973

Works in summer and early autumn on silkscreens at Gemini G.E.L. workshop. George Page, Master Printer, begins work at the Litho Shop, Inc. In fall, leaves Santa Monica with his wife and sons for a one-year stay in Tokyo. Solo exhibitions at Pace Editions, New York; André Emmerich Gallery, New York; Galerie Smith Andersen, Palo Alto; Galerie Jean Fournier, Paris; Kornfeld and Cie, Berne; De Saisset Gallery, Santa Clara; Albright-Knox Art Gallery, Buffalo; and Nicholas Wilder Gallery, Los Angeles. Begins to create *Self-Portraits* on paper and lithographic editions. In the paintings, color within the picture surface has returned, frequently beam-like constructions dominate as in *Permanent Water*. White recesses or intensively painted quadrangular surfaces infer mandala forms which continue to evolve, especially in works on paper through 1976.

1974

Lives and works until autumn in Tokyo. Returns to California with stops along the way to Berne and Paris. First exhibition in South America at Fundación Eugenio Mendoza, Caracas, Venezuela, a retrospective of works on paper and prints. Documentation of the Idemitsu Collection of Sam Francis Works through published catalogue and major exhibition at the Idemitsu Art Gallery, Tokyo. United States Information Service organizes traveling exhibition at American Centers in Japan. Solo shows at Gimpel Fils, Ltd., London; Galerie Pudelko, Bonn; Martha Jackson Gallery, New York; Robert Elkon Gallery, New York; Idemitsu Art Gallery, Tokyo; Galerie La Tortue, Santa Monica; Margo Leavin Gallery, Los Angeles; Minami Gallery, Tokyo; Nantenshi Gallery, Osaka; Portland Visual Art Center, Portland; Esther Bear Gallery, Santa Barbara; Gemini G.E.L., Los Angeles; La Galerie A. and G. de May, Chailly-Village; and Galerie d'Art Moderne, Basel.

1975

Resides in Santa Monica. Independently publishes a book of his aphorisms in conjunction with June exhibition at Nicholas Wilder Gallery. Begins collaboration with Mark Whitney, Michael Whitney, George Wagner and Suzanne

Wagner on film about the psychoanalyst Carl G. Jung, *Matter of Heart*. With Mark Whitney, begins film on Francis' painting. Starts monotypes in Santa Cruz and San Francisco at the Institute of Experimental Printmaking with Garner and Ann Tullis. Founds the Wind Harvest Company with inventor and engineer Robert Thomas for the study and the development of windmills in order to produce ecological alternatives to electrical and nuclear energy. Initial publication of Peter Selz's comprehensive monograph *Sam Francis* by Harry N. Abrams, Inc., New York, with essay by Susan Einstein and contributions by friends and critics Shuzo Takiguchi, Bernard Forrest, Makoto Ooka, Rachel Jacobs, Yoshiaki Tono and Walasse Ting. (Revised 1982 with additional text by Jan Butterfield.) Solo exhibitions at Nicholas Wilder Gallery, Los Angeles; Smith Andersen Gallery, San Francisco; André Emmerich Gallery, New York; Galerie Jean Fournier, Paris; Galerie Kornfeld, Zurich; Richard Gray Gallery, Chicago; Galerie Bonnier, Geneva; and Los Angeles Valley College, Van Nuys. The imagery in the painting, formerly very freely composed beam-like elements, begin to thicken partly to very colorful and often dark lattice-like constructions as in *Facing Within*.

1976

Resides in Santa Monica with sojourns to Berne, Paris and Tokyo. *Sam Francis*, a 52 minute 16mm color film is completed by Michael Blackwood (Blackwood Productions, Inc.). Solo exhibitions at Galerie Jean Fournier, Paris; Margo Leavin Gallery, Los Angeles; Los Angeles Pierce College Art Gallery, Los Angeles; Smith Andersen Gallery, Palo Alto; Contemporary Art Forms, Encino; and André Emmerich Gallery, New York.

1977

First exhibition of self-portraits at Galerie Kornfeld und Klipstein, Berne, and Minami Gallery, Tokyo, in memory of Frank Perls, a Los Angeles Art Dealer. Major exhibition entitled *Art in Progress* at the Louisiana Museum of Modern Art, Humlebaek, Denmark. Receives commission from his long-time friend Knud W. Jensen, Director at the Louisiana Museum, to make two paintings for the new concert hall as well as creating three suites of lithographs entitled the *Concert Hall Set*. The Scaler Foundation gifts *In Lovely Blueness I* (1955-57) to the Musée national d'art moderne, Centre Georges Pompidou, Paris. Solo exhibitions at Honolulu Academy of Art (lithographs) where he juries an art show; Althann Gallery, Los Angeles; Galerie Beyeler,

Basel Art Fair; Christoph Pudelko, Bonn; and Galerie Kornfeld, Zurich. Begins working on "web" series in which the structure is more maze-like as in *Easter, Blue Arc* and *Joyous Lake*. Grid-like formations begin to show up through the works on paper in diptychs and triptychs. Exhibits work on Japanese paper mounted on canvas drummed structures along with large format canvases. Monotypes begin to utilize raw pigment and bolder gestural brushstrokes on handmade paper after delicate folded series (1975-76).

1978

Establishes a large painting studio and moves the Litho Shop, Inc., to 2058 Broadway in Santa Monica. Jerry Sohn begins work for Francis as studio assistant. Extensive exhibition of recent work organized by Pontus Hulten at the Musée national d'art moderne, Centre Georges Pompidou, Paris (curated from work in *Art in Progress* at Louisiana Museum; later travels to Liljevalchs, Stockholm, and Israel Museum, Jerusalem, from 1978-79). Large grid canvases exhibited at the Otis Art Institute, Los Angeles. Completes lithograph for a portfolio published by Nantenshi Gallery, Tokyo, honoring Kusuo Shimizu of Minami Gallery. Friendship with artist Liga Pang. Solo exhibitions at Nicholas Wilder Gallery, Los Angeles; Thomas Segal Gallery, Boston; Galerie Gunzenhauser, Munich; and Smith Andersen Gallery, Palo Alto. Matrix paintings evolve to more darkly painted work with interspersed watery channels as in *Dark Beams*.

1979

Large retrospective survey of works on paper at the Institute of Contemporary Art, Boston, organized by Stephan S. Prokopoff and Elizabeth Sussman which later travels through the United States International Communication Agency to Phillipines, Taipei, Hong Kong, and Korea through 1981. Completion and installation of mural *Seafirst* at Seattle First National Bank, Seattle. Solo exhibitions at André Emmerich Gallery, New York; Maxwell Davidson Gallery, New York; Robert Elkon Gallery, New York; Brooke Alexander, Inc., New York, Galerie Jean Fournier, Paris; Galerie Madoura, Vallauris; Cantor/Lemberg Gallery, Birmingham; Minami Gallery, Tokyo; Boise Gallery of Art, Boise; Foster Goldstrom Fine Arts, Inc., San Francisco; Ace Gallery, Vancouver; Gemini G.E.L., Los Angeles; Richard Hines Gallery, Seattle; Thomas Segal Gallery, Boston; and Ace Gallery/Nicholas Wilder Gallery, Venice, California. Paintings become more grid-like and anchored in front of the white space as exemplified in *Requiem for Shimizu*.

1980

January and February are spent in Switzerland (Zurich and Berne) and Paris. In Zurich, works on film about C.G. Jung. Returns to Santa Monica, after spending the summer in France and Switzerland. Receives commissions to paint a mural, *Spring Thaw,* for the Federal Building U.S. Courthouse in Anchorage, Alaska, commissioned by the General Services Administration and an *Untitled* diptych mural for Weinstock's Department Store, Sacramento, California. Invited by the Renault corporation to organize (works with Claude and Micheline Renard) a one-person exhibition of new work at the Romanesque Abbaye de Sénanque, Gordes, France. Exhibition of monotypes at Los Angeles County Museum. Elected to the Board of Trustees of The Museum of Contemporary Art, Los Angeles, and to membership in its Architectural Committee, where he is integral to the appointment of Pontus Hulten as Founding Director and Arata Isozaki as architect for the permanent building. (Temporary Contemporary opens 1983; MOCA inaugurated in 1986.) Receives commissions to paint a triptych mural for the San Francisco International Airport (the United Airlines Terminal, completed 1981) and a large five panel painting for the San Francisco Museum of Modern Art (completed 1985-86). Inducted into the Academy and Institute of Arts and Letters (39th award ceremony). Solo exhibition at Phillips Collection, Washington, D.C., as well as at James Corcoran Gallery, Los Angeles; Riko Mizuno Gallery, Los Angeles; Asher/Faure Gallery, Los Angeles; Smith Andersen Gallery, Palo Alto; Foster Goldstrom Fine Arts, Inc., San Francisco; and Gallery 210, St. Louis. Grid structure on paintings begin to disintegrate and break up into globular chaotic forms as seen in *Simplicity*.

1981

Lives and works in Santa Monica. Establishes large mural studio in San Leandro, California, for the Museum of Modern Art, San Francisco, commission. Receives commission to create a print for the Presidential Portfolio through the Democratic National Committee. Monotypes become larger in scale, particularly exemplified in the red cross series. Included in *Seventeen Artists in the Sixties,* Los Angeles County Museum. Solo exhibitions at André Emmerich Gallery, New York; Ace Gallery, Los Angeles and Venice, California; Faith and Charity in Hope Gallery, Idaho; and Ruth Schaffner Gallery, Santa Barbara. Paints series of intersections or cross-like structures as if they were fragmented close-ups of the larger grid work.

1982

Installs an etching studio at the Litho Shop enlisting Jacob Samuel, Master Etcher. Contributes a text, *Notes on Jackson Pollock,* to the exhibition catalogue of Pollock's work at the Musée national d'art moderne, Centre Georges Pompidou, Paris. Nantenshi Gallery, Tokyo, represents Francis after the death of Kusuo Shimizu and the closure of the Minami Gallery. Solo exhibitions at Nantenshi Gallery, Tokyo; André Emmerich Gallery, New York; Richard Gray Gallery, Chicago; Galerie Niepel, Düsseldorf; Pamela Auchincloss Gallery, Santa Barbara; Makler Gallery, Philadelphia; and Galerie Au Poisson Rouge, Praz/Vully. Begins to utilize wood planks in monotypes in conjunction with gestural painting which reveal the grain through color.

1983

Studio in Paris at Arcueil is razed. Studios maintained in Tokyo, Santa Monica, Palo Alto and San Leandro. In February, participated with 350 artists and intellectuals, gathered for a symposium organized by Jack Lang, French Minister of Culture in Paris, focussing on the crisis in culture. By order of the French Ministery of Culture, Francis is named Commandeur de L'Ordre des Arts et des Lettres, and receives commissions to paint a ceiling in the Louvre and to design stained glass windows for a church in France (both commissions never realized). Traveling exhibition throughout the United States organized by Art Museum Association of America (1983-1985) of works on paper and monotypes. Major exhibition at Fondation Maeght, Saint-Paul-de-Vence, France. Solo exhibitions include André Emmerich Gallery, New York; Smith Andersen Gallery, Palo Alto; Colorado State University, Fort Collins; Galerie Kornfeld, Berne; Studio Marconi, Milan; Galerie Jean Fournier, Paris; Thomas Segal Gallery, Boston; John Berggruen Gallery, San Francisco; Nantenshi Gallery, Tokyo; Jane Kahan Gallery, New York; and Art Attack Gallery, Boise. Works in smaller scale and paints on shaped canvases.

1984

Lives and works primarily in California and Tokyo. In Tokyo, he becomes acquainted with the English painter, Margaret Smith who lives and works there. Death of his stepmother, Virginia Francis. Founds Lapis Press (with Jack Stauffacher and Jan Butterfield) which was initially set up in the Litho Shop as a letterpress and trade book publisher of books on the visual arts, poetry, psychology, literature, philosophy and criticism, as well as limited edition artists'

books. Press assisted by Jaime Robles and Les Ferriss. Contributes a lithograph to *Eight by Eight to Celebrate the Temporary Contemporary,* a portfolio of prints by eight artists for the Museum of Contemporary Art, Los Angeles. Solo exhibitions include Galerie Humanite, Nagoya; Kasahara Gallery, Osaka; Galerie Pudelko, Bonn; André Emmerich Gallery, New York; Brooke Alexander, Inc., New York; Robert Elkon Gallery, New York; Knoedler Gallery, London; Warwick Arts Trust, London; Thomas Babeor Gallery, La Jolla; Pamela Auchincloss Gallery, Santa Barbara; Cantor/Lemberg Gallery, Birmingham; and Gemini G.E.L., Los Angeles. The painting of this year is characterized by vigorous color in reed-like composition, in some cases with poured color effects and in several elements – up to six components – arranged serially in diptychs, triptychs and quadruple panels as build up to San Francisco Art Museum commission. Francis also creates a screen of painted acrylic on five hollow core wooden panels (10 sided) prepared with gesso ground, *The Bound and the Unbound.*

1985

Lives and works in Santa Monica, Palo Alto and San Leandro studios. Travels to Paris and Berne for exhibitions. Beginning of a series of interviews with art critic Yves Michaud, published through Galerie Jean Fournier. (*Entretiens* 1985, 1988.) Solo exhibitions at National Gallery of Art, Washington, D.C.; Galerie Kornfeld, Zurich; Nantenshi Gallery, Tokyo; Galerie Jean Fournier, Paris; Smith Andersen Gallery, Palo Alto; Richard Gray Gallery, Chicago; and Hokin Gallery, Bay Harbor Island.

1986

Marriage with Margaret Smith and birth of third son, Augustus James Joseph in Santa Monica. House with potential studio is purchased in Paris on Rue Georges Braque. Major one-person exhibition, *L'Oeuvre de Sam Francis dans les collections du Musée Idemitsu* at Pavillon des Arts, Paris (travels to Louisiana Museum, Humlebaek, Denmark, and Yayoi Gallery, Ogawa Art Foundation, Tokyo 1986-87). Receives commission to paint mural for the ceiling of the Opéra National, Théâtre Royal de la Monnaie, Brussels. (Triptych completed that year.) Completes a suite of lithographs, *Poèmes dans le Ciel,* in conjunction with the publication of Sam Francis monograph *Métaphysique du Vide* by poet Michel Waldberg (published 1987). Solo exhibitions at Sierra Nevada Museum of Art, Reno; Galerie Jean Fournier, Paris; André Emmerich Gallery, New York; Pamela Auchincloss Gallery, Santa Barbara; Stephen Wirtz

Gallery, San Francisco; Bernard Jacobson Gallery, New York; Chicago Art Fair; Smith Andersen Gallery, Palo Alto; Angles Gallery, Santa Monica; Gemini G.E.L., Los Angeles; Michael Dunev Fine Arts, San Francisco; and Le Maire de Paris, Paris. Paintings during this time explode as shapes congregate in clusters of color on the canvas, exemplified in *Taiaisha*.

1987

Lives and works in both Santa Monica and Palo Alto. Founds the Sam Francis Medical Research Center, Inc., to support research on infectious and environmental diseases (coordinated by Robert H. Jacobs, MD, and consultants Prof. Dr. Jordan U. Gutterman, Houston, Texas, and Prof. Dr. Silvio Barandun, Berne). Robert Shapazian joins Lapis Press as director and editor. Collaborates with poet Kathleen Fraser on a suite of six aquatints integrated with the poem *Boundayr*. Completes screenprint entitled *Red Star* at La Paloma workshop to commemorate the 20th Anniversary of the American Film Institute, Los Angeles. Solo exhibitions at Nantenshi Gallery, Tokyo; André Emmerich Gallery, New York; Knoedler Gallery, London; Galerie Kornfeld, Zurich; Heland Thorden Wetterling Galleries, Stockholm; Manny Silverman Gallery, Los Angeles; Galerie Pudelko, Bonn; George Dalsheimer Gallery, Baltimore; Galerie Arethon, Paris; Kass/Meridian Gallery, Chicago; Loma Linda University, Riverside; Galeria Eude, Barcelona; Galerie Alice Pauli, Lausanne; and Pamela Auchincloss Gallery, Santa Barbara.

1988

Lives and works primarily in Santa Monica and Palo Alto with a two-month sojourn to Tokyo. Purchases property in Inverness, California, to develop a residence and studio. Major exhibition of eighties work organized by the Museum of Modern Art, Toyama, which travels through 1989 in Japan to the Museum of Modern Art, Seibu Takanawa, Karuizawa; The Museum of Modern Art, Shiga; Ohara Museum of Art, Kurashiki; and Setagaya Art Museum, Tokyo. Completes two screenprints; one for the 25th Anniversary of the Music Center of Los Angeles County and the other for Crossroads School, Santa Monica, California. Completes project of making kite for the Goethe Institute of Osaka using an aquatint etching to be included in a group exhibition traveling throughout Europe and Japan. Studio assistants during this time are Doug Shields, John Haines, Brian Forrest. Solo exhibitions at Smith Andersen Gallery, Palo Alto; Bernard Jacobson Gallery,

London; Galerie de Seoul, Seoul; Galerie Jean Fournier, Paris; The Greenberg Gallery, St. Louis; The Art Store, Los Angeles; Michael Dunev Fine Arts, San Francisco; and the Green Valley Library Cultural Center Gallery, Las Vegas. Begins series of work which continues through 1990 that are primarily swirling, gestural masses of green paint with clots of poured color interspersed on the canvas as in *Out of Albion*.

1989

Establishes studio in Point Reyes Station, California. Deeply grieved by the deaths of Edwin Janss, Jr, and James Kirsch. Becomes increasingly involved in supporting alternative medical research due to his own specific illness, prostate cancer. Letterpress studio in Emeryville established with Les Ferriss. Completes screenprint for public television station, WNET-13, entitled *For Thirteen* and lithograph (originally created at Gemini G.E.L.), entitled *Falling Star*, donated to benefit the Foundation for Contemporary Performance Art, Inc. Jan Anderson and George Page assume directorship of the Litho Shop with Beth Silverman as administrative assistant. Crossroads School in Santa Monica, California, inaugurates Sam Francis Gallery at the Peter Boxenbaum Art Education Center. Solo exhibitions at André Emmerich Gallery, New York; Galerie Jean Fournier, Paris; Galerie Kornfeld, Zurich; Knoedler Gallery, London; Bernard Jacobson Gallery, London; Gallery Ikeda-Bijutsu, Tokyo; Inoue Gallery, Tokyo; Cantor/Lemberg Gallery, Birmingham; Linda Farris Gallery, Seattle; and Sun Valley Center for the Arts and Humanities, Sun Valley.

1990

Alternating stays in Santa Monica, Inverness, Palo Alto and Point Reyes Station. Establishes business quarters up north run by Theresa and Krauth Brand. Travels to England and Scotland. Completes *For the Blue Sons of the Air*, a screenprint for the Artists for American Indians, American Indian Heritage Foundation. Begins re-translating and creating works on paper in Northern California for book on Nietzsche aphorisms on art. Begins collaboration with poet Pierre Guyotat on forthcoming book *Wanted Female* for Lapis Press. Major exhibitions at Yayoi Gallery, Ogawa Art Foundation, Tokyo, and Glasgow Museums and Art Galleries, Kelingrove (travels to Talbot Rice Gallery, Edinburgh). Solo shows at André Emmerich Gallery, New York; Smith Andersen Gallery, Palo Alto; Galerie Delaive and Galerie Willy Schoots at Arti et Amicitiae, Amsterdam; Edinburgh Printmakers Workshop, Edinburgh; Associated

American Artists, New York; Heland Wetterling Galleries, Stockholm; Ochi Gallery, Sun Valley; Takashi Gallery, Tokyo; Foster Goldstrom Gallery, New York; and Jane Kahan Gallery, New York.

1991

Resides in Santa Monica, Palo Alto and Point Reyes Station with travels to Europe. Forty year retrospective exhibition at Galerie Kornfeld, Berne, accompanied by a catalogue featuring a personal chronology by Eberhard W. Kornfeld. Participates in *Mémoire de la Liberté,* a portfolio of 51 artists in Universal Declaration of Human Rights. Creates portfolio of 7 lithographs in conjunction with *Sam Francis,* a major monograph by Yves Michaud, published in 1992. (Edition Daniel Papierski, Paris.) Presented with the Art/LA91 International Arts Award. Major exhibition at Centre régional d'art contemporain Midi-Pyrénées, Labège, France. Solo shows at Galerie Jean Fournier, Paris; James Corcoran Gallery, Santa Monica; Angles Gallery, Santa Monica; Gagosian Gallery, New York; Associated American Artists, New York; Gana Art Gallery, Seoul; Galerie Kornfeld, Zurich; and Galerie Urs Meile, Lucerne.

1992

Lives primarily in Santa Monica, Palo Alto, and Point Reyes Station. Publication of *The Prints of Sam Francis: A Catalogue Raisonné* by Connie W. Lembark and Ruth E. Fine. Receives commission to do a monumental painting for the Deutscher Bundestag, the new federal parliament building in Bonn, architect Günter Behnisch (due to illness an already existing painting was eventually substituted). Litho Shop administrative staff addition includes Debra Burchett-Lere as co-director with George Page. Major retrospective of works on paper organized by Galerie Delaive for the Museum van der Togt, Amstelveen. Solo exhibitions at André Emmerich Gallery, New York; Associated American Artists, New York; Kukje Gallery, Seoul; Smith Andersen Gallery, Palo Alto; Tobias Loeffel, Basel; and Galerie Daniel Papierski, Paris.

1993

Resides in Santa Monica primarily, traveling to Bonn, Mexico and Point Reyes Station during the year. Publication through Lapis Press of *Sam Francis Lesson of Darkness. Like the painting of a blind man* by Jean-François Lyotard. Major retrospective, organized by Pontus Hulten and assisted by Uta Grosenick, at the Kunst- und Ausstellungshalle der Bundesrepublik Deutschland, Bonn, accompanied by major catalogue. Francis gifts Museum of Contemporary Art, Los Angeles, with 10 works for their permanent collection. It is the largest donation to a museum by a single artist. Solo exhibitions at Galerie Pudelko, Bonn; Galerie Jean Fournier, Paris; Galerie Kornfeld, Berne; Manny Silverman Gallery, Los Angeles; Bobbie Greenfield Fine Art, Venice, California; Michel Cohen Gallery, New York; Basel Art Fair; Galerie Iris Wazzu, Davos; Robert Green Fine Arts, Ross; and Ochi Fine Art, Ketchum.

1994

Death of Sam Francis on November 4, due to complications from prostate cancer. Publication of *Sam Francis* by Makoto Ooka as part of the Contemporary Great Masters series in Tokyo and *The Monotypes of Sam Francis,* published by Daco-Verlag, Stuttgart, Germany. Major exhibition at the University Art Museum, University of California, Berkeley, in which Francis receives the 1994 UC Berkeley Art Department Distinguished Alumnus Award and the establishment in his honor of the Sam Francis Graduate Student Endowment Fund. Awarded the MTG'94 Grand Prix d'Honneur at International Print Triennial Society, Muzeum Narodowe W. Krakowie, Poland. Solo exhibitions at Galerie Jean Fournier, Paris; Galerie Kornfeld, Berne; Galerie Delaive, Amsterdam; André Emmerich Gallery, New York; Long Fine Art, New York; Bobbie Greenfield Fine Art, Venice, California; Nantenshi Gallery, Tokyo; Galerie Proarta, Zurich; Richard Gray Gallery, Chicago; Barbara Scott Gallery, Bay Harbor Islands; Cumberland Gallery, Nashville; Riva Yares Gallery, Santa Fe; Baukunst, Cologne; Galerie 224, Laguna Beach; and Daco-Verlag, Stuttgart.

1995

Major exhibition *Sam Francis, The Shadow of Colors,* works on paper from 1947-1977, at Kunstverein Ludwigsburg near Stuttgart, Germany (travels to Louisiana Museum of Modern Art, Humlebaek, Denmark and Städtische Kunstsammlungen Chemnitz, Germany). Exhibition *Constellation of Light and Dark,* black and white works on paper (1947-1954) at Grunwald Center for the Graphic Arts, UCLA, at the Armand Hammer Museum of Art, Los Angeles. Installation of the small paintings from Santa Monica studio, 1994, Sam Francis' last works, at the Los Angeles County Museum of Art, Los Angeles (travels through 1996). Memorial shows at André Emmerich Gallery, New York and Manny Silverman Gallery, Los Angeles.

The Authors

Susanne Anna (Chemnitz), director of the Städtische Kunstsammlungen Chemnitz, since 1992.

Nico Delaive (Amsterdam), a Dutch art dealer, he was a friend of Sam Francis.

Pontus Hulten (Bonn/Paris), director general of the Kunst- und Ausstellungshalle der Bundesrepublik Deutschland, Bonn. He organized the 1993 Sam Francis retrospective exhibition in Bonn.

Peter Iden (Frankfurt am Main), chief arts editor of the German daily Frankfurter Rundschau and professor at the Hochschule für Musik und darstellende Kunst in Frankfurt am Main.

Knud W. Jensen (Humlebaek/Copenhagen), founding director of the Louisiana Museum in Humlebaek near Copenhagen. Regarded by many as the world's most beautiful museum, the Louisiana has one of the most impressive public collections of works by Sam Francis.

Kiki Kogelnik (New York), an Austrian artist now living in New York, she was a close friend of Sam Francis.

Ingrid Mössinger (Ludwigsburg/Frankfurt am Main), responsible for the concept and organization of the exhibition *Sam Francis – The Shadow of Colors*, director of the Kunstverein Ludwigsburg.

Nancy Mozur (Santa Monica, California) worked with Sam Francis for many years and ran The Litho Shop from 1973 – 1989.

Tilman Osterwold (Stuttgart) has been a member of staff of the Kunsthalle Hamburg (1970-71) and the Wilhelm-Lehmbruck-Museum in Duisburg (until 1973) and was director of the Württembergischer Kunstverein Stuttgart. He is honorary professor of art history at the University of Stuttgart.

Wieland Schmied (Salzburg/München) was professor of art history at the Akademie der bildenden Künste in Munich until 1994 and is now president of the Internationale Sommerakademie für bildende Künste in Salzburg.

Robert Shapazian (Venice, California) is director of The Lapis Press founded by Sam Francis in 1984. He took his doctorate at Harvard and is a member of the photographic committee at the Metropolitan Museum of Art in New York.

This catalogue has been published to accompany the exhibition *Sam Francis – The Shadow of Colors*.
Conception of the exhibition and the catalogue: Ingrid Mössinger

Kunstverein Ludwigsburg, Villa Franck, Franckstrasse 4, 71636 Ludwigsburg, Germany
Board members: Martin Hagenmüller, Richard Gänzle, Doris Jahnke, Uwe Kraus
Director: Ingrid Mössinger

Louisiana Museum of Modern Art, 3050 Humlebaek, Denmark
Founding Director: Knud W. Jensen
Director: Steingrim Laursen
Curator: Helle Crenzien

Städtische Kunstsammlungen Chemnitz, Theaterplatz 1, 09111 Chemnitz, Germany
Director: Susanne Anna
Curator: Kerstin Drechsel

Photo credits: Richard Allen

Unless otherwise specified, all works reproduced are signed and dated on the back
and bear the stamp of the Estate of Sam Francis.
Dimensions height by width

**All the works reproduced in this publication have been kindly loaned by
The Estate of Sam Francis and The Sam Francis Art Foundation,
c/o The Litho Shop, Inc., Santa Monica, California**

Reproduction copyright by The Estate of Sam Francis and The Sam Francis Art Foundation,
c/oThe Litho Shop, Inc., Santa Monica, California
Text copyright by the authors
Translation of the texts by Susanne Anna, Nico Delaive, Pontus Hulten, Peter Iden,
Kiki Kogelnik, Ingrid Mössinger, Tilman Osterwold and Wieland Schmied
from the German by Ishbel Flett
Translation of the texts by Knud W. Jensen from the Danish by Ernst Dupont
Art direction and typography by Peter Renn, Teufen, Switzerland
Photolithography by Amilcare Pizzi S.p.A., Cinisello Balsamo (Milano), Italy
Printed and bound by Amilcare Pizzi S.p.A., Cinisello Balsamo (Milano), Italy

ISBN 3-905514-85-0